Images of Modern America

CONGAREE NATIONAL PARK

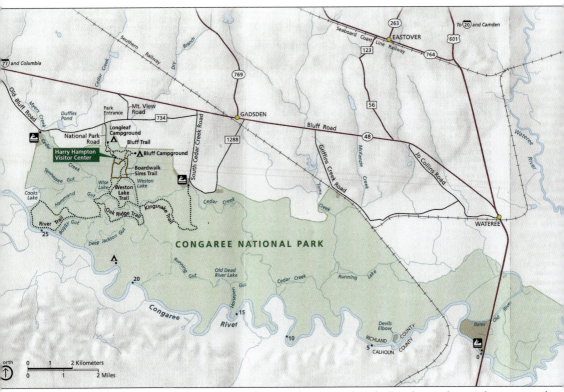

Congaree National Park is South Carolina's only national park. It is located near the center of the state in Richland County, 12 miles south of Columbia, the state capital. (Courtesy of the National Park Service [NPS].)

FRONT COVER: Park rangers conduct a nature walk on the low boardwalk. (Courtesy of jt-FINEart.com.)

UPPER BACK COVER: Canoeing is a popular way to experience the mystery and beauty of Congaree National Park. (Courtesy of the NPS.)

LOWER BACK COVER (from left to right): Early spring in the park means lush stands of butterweed in bloom (Courtesy of the NPS; see page 44), the park's first ranger station was replaced in 2001 by the Harry Hampton Visitor Center (Courtesy of the NPS, see page 33), naturalists marvel at the size of Congaree's state champion bald cypress (Courtesy of Joe Kegley; see page 53.)

Images of Modern America

CONGAREE NATIONAL PARK

John E. Cely

Copyright © 2017 by John E. Cely
ISBN 978-1-4671-2642-7

Published by Arcadia Publishing
Charleston, South Carolina

Printed in the United States of America

Library of Congress Control Number: 2016962522

For all general information, please contact Arcadia Publishing:
Telephone 843-853-2070
Fax 843-853-0044
E-mail sales@arcadiapublishing.com
For customer service and orders:
Toll-Free 1-888-313-2665

Visit us on the Internet at www.arcadiapublishing.com

John Grego is the long-serving president of Friends of Congaree Swamp and a tireless advocate for Congaree National Park. (Courtesy of Rhonda Grego.)

CONTENTS

Acknowledgments 6
Introduction 7
1. Early History 9
2. Saving the Swamp 17
3. Park Beginnings 29
4. A New Century for the Park 41
5. Natural History 49
6. Park Activities 87

ACKNOWLEDGMENTS

This book would not have been possible without the excellent cooperation and assistance from the staff of Congaree National Park. Scott Teodorski, chief of interpretation, first suggested my name to Arcadia Publishing when they contacted him about a book on the park (thanks Scott!). Scott went out of his way searching park digital photograph files and offering other support that made this a better book. Other staff that provided help, including reviewing all or parts of the book, were Greg Cunningham, Theresa Yednock, David Shelley, Frank Henning, Liz Struhar, and park superintendent Tracy Stakely. Retired park ranger Fran Rametta provided the institutional memory it took for clarifying dates, personnel names, and events of 30 or more years ago. Mark Kinzer of the park service's Atlanta regional office offered invaluable assistance with a timeline of significant events during the park's 40-year history and also reviewed the text part of the book. Martha Bogle helped clarify dates and details from her significant tenure as park superintendent from 1995 to 2005. Will Blozan of the Native Tree Society provided helpful information on the heights and dimensions of Congaree's remarkable trees.

I am indebted to the fine photographers who have shared their images of Congaree National Park for this book. They are Ron Ahle, Jerry Bright, Sparkle Clark, John Grego, Rhonda Grego, Caroline Grego, Joe Kegley, J.T. Martin, Steve Pittman, Leo Rose, David Schuetrum, George Taylor, James and Jenny Tarpley, Robert Van Pelt, Richard Watkins, and Don Wuori. James and Jenny Tarpley of VISIO Photography (jt-FINEart.com) were Congaree's first artists-in-residence and have generously allowed the use of some of their superb photography. All photographs from the respective photographers are copyrighted.

The Maryland Institute College of Art (MICA), through an intern program with Congaree, has given its students a unique opportunity to conduct photography within the park. Some of the excellent work of Paul Angelo, Steven McNamara, and Ted Schantz appear in this book.

I thank the American Museum of Natural History for the use of Richard Pough's photograph and the University of North Carolina Press for allowing the use of the dustcover from *A New Voyage to Carolina* by John Lawson. It was edited by Hugh Talmadge Lefler and copyrighted 1967 by the University of North Carolina Press (www.uncpress.unc.edu). The Gibbes Museum of Art/Carolina Art Association kindly permitted use of Col. William Thomson's portrait. The University of South Carolina's Public History Program allowed the use of the figure at the top of page 15.

INTRODUCTION

The 26,539-acre Congaree National Park is located in rural lower Richland County in central South Carolina, a few miles south of the capital city of Columbia. Most of it consists of a low-lying floodplain forest two and a half to three and a half miles wide adjacent to the Congaree River, with a small portion along the lower Wateree River. Both are large "brown" rivers, meaning they carry loads of muddy sediment during flood events that occur within a 14,000-square mile watershed that stretches into western North Carolina. There are 28 miles of park riverfront along the north bank of the Congaree River and another four miles of frontage along the west bank of the Wateree River.

Congaree National Park is not a true swamp, in the sense of there being permanent, standing water that requires a boat for access, but is a floodplain or bottomland forest that may flood a few times each year, typically in late winter and early spring. The rest of the year most of the forest floor is dry and suitable for walking and hiking.

Congaree is the largest expanse of old-growth bottomland forest remaining in the United States. When the first white settlers arrived 400 years ago, some 50 million acres of bottomland forest existed along coastal rivers that stretched from southern Virginia to eastern Texas and north to Missouri. Now, only about half that amount exists. The remainder has been cleared for agriculture, logged, drained, channelized, filled, and flooded. The cut-over second- and third-growth forests that remain are far different from the original forest, a highly complex and diverse one characterized by a tall, dense tree canopy and plentiful fish and wildlife.

Researchers have documented nearly a hundred species of trees at Congaree National Park, almost as many as the entire Pacific Northwest. And in terms of total woody plants—trees, shrubs, and vines—Congaree ranks second among national parks, being surpassed only by the Great Smokies, which is 20 times bigger. The large number of native vine species at Congaree, 26 (more than any other park), lends a characteristic subtropical feel to the place. Due to its pristine condition, fertile soils, abundant moisture and sunshine, and long growing season, Congaree supports one of the tallest hardwood forests anywhere in the temperate world. Five of the seven species of oak trees that regularly occur in the Congaree floodplain, for example, are the tallest ever measured for the species. One of these, a cherrybark oak 160 feet high, is the tallest oak tree ever measured in North America. Few areas of its size can boast of the number of national and state champion record trees as Congaree, a feature that has resulted in it being dubbed the "Forest of Champions."

But Congaree National Park is about much more than big, record-setting trees. It is a highly complex forest, in fact one of the most biologically diverse within the national park system, shaped by active and always-changing coastal rivers that regularly flood and deposit rich layers of sediment on the floodplain floor. Unlike most national parks that are like islands surrounded by a sea of development, Congaree is an "open" or "flow-through" system and vulnerable to events that may occur many miles away from its boundaries.

Old-growth bottomland hardwood forests are some of the richest and rarest environments anywhere in the temperate world. One hallmark of these forests is the large amount of dead and dying wood, both standing and on the ground, a feature that results in unusually high populations of woodpeckers, owls, and other cavity-dependent wildlife. Another is an abundance of oak trees that yield rich crops of nature's perfect wildlife food—acorns. Bottomland forests are inseparable from the rivers that feed and nourish them. They serve as spawning and nursery grounds for many fish species and link the aquatic world with the terrestrial one, a merging that supports river otters, beavers, waterfowl, and wading birds on the same ground as white-tailed deer, wild turkey, raccoons, and gray squirrels.

Although small and young by most park standards, Congaree National Park is unique within the national park system. It can be thought of as an outdoor, living museum that provides a rare glimpse into America's past, a past as a hunting and fishing ground for Native Americans, a place where thousand-year-old cypress trees, still standing, collected the dust of De Soto's passing army of Spanish conquistadors and witnessed the smoke and noise of Revolutionary War battles, a past where escaped slaves hid out, and ivory-billed woodpeckers, Carolina parakeets, wolves, panthers, and bears lived and roamed.

The park was first established as Congaree Swamp National Monument in 1976 after a citizens' grassroots campaign saved it from logging. Twenty-seven years later, in 2003, it became the nation's 57th national park when its name was changed to Congaree National Park. During its 40-year history, the park has been designated an international biosphere reserve, a globally important bird area, and a Ramsar Wetland of International Importance. Much of the park, nearly 22,000 acres, has been designated as official wilderness under the National Wilderness Preservation System.

That this extraordinary park lies on the doorsteps of more than half a million people is an open invitation to come visit. A Sunday afternoon stroll on the 2.4-mile boardwalk loop is a great introduction. For hikers, more than 30 miles of trails through a magnificent, cathedral-like forest await. Other activities include camping, fishing, birding, photography, and nature study. The park offers a variety of ranger-led programs, with paddles on scenic Cedar Creek and nocturnal "Owl Prowls" being some of the most popular. In recent years, the word has gotten out about Congaree's synchronous lightning bug display in late May. It only lasts for about two weeks, and the parking lot is guaranteed to be full.

Whether it be for a few hours for the first-time visitor or the thousandth time for park veterans, it is almost guaranteed that there will be something new to see in this ever-changing and timeless place.

One
EARLY HISTORY

Many authorities think that Hernando De Soto's famous exploration of the southern United States brought him and his army of 600 Spanish conquistadors to the edge of Congaree Swamp in the spring of 1540. At that time, the Congaree River valley, because of its fertile soils and abundant fish and game, had been occupied by Native Americans for thousands of years. The name of one such tribe was later bestowed upon the river and the big floodplain forest that bordered it. It was not until the early 1700s that the first white settlers began settling into "the Fork," as lower Richland County was formerly known. The rich alluvial bottomlands of the Congaree Swamp made excellent agricultural lands once the heavy forest was cleared. This required intensive hand labor that soon gave rise to a slave-based plantation system. The first plantings in these cleared bottomlands, primarily along the fertile riverbank, were indigo and a scattering of rice, later followed by cotton, corn, wheat, oats, peas, beans, and other crops. After the Revolutionary War, many of the smaller tracts within the Congaree were consolidated into large plantations. The swamp was also prime grazing land for free-ranging cattle and swine. Semipermanent cow pens, or corrals, were established in the swamp, as were earthen cattle mounds to provide refuge for livestock during floods.

The Civil War ended the antebellum plantation economy. Money became scarce, and land values were depressed. In the 1880s, lumber pioneer Francis Beidler I came to South Carolina and purchased thousands of acres of bottomland forest along the Congaree, Wateree, and Santee Rivers to harvest extensive stands of virgin bald cypress that grew in these swamps. His Santee River Cypress Lumber Company became one of the biggest lumber operations in South Carolina. Cypress was the wood of choice at Beidler's Congaree property, and most of the old-growth hardwoods and pines flourished and remained untouched until 1969, when logging resumed after a 50-year absence. By then, however, the word had gotten out about the big trees of Congaree, and the stage was set for the next episode of the Congaree National Park story.

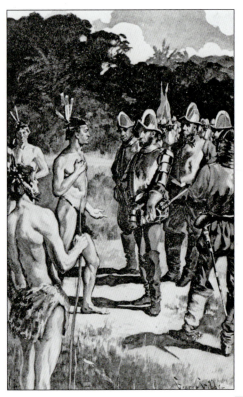

In the spring of 1540, Hernando De Soto's army of 600 Spanish conquistadors passed near the Congaree while searching for the legendary Indian village of Cofitachequi. De Soto's expedition was the very first contact between Europeans and Native Americans of the Southern interior. One can only imagine the reaction Indians had to seeing strange bearded white men mounted on horses and carrying armor and firearms. (Courtesy of the Library of Congress.)

John Lawson provided some of the first and best accounts of the native peoples and natural history of early South Carolina. He passed near the Congaree National Park in January 1701 and spent time with the Congaree Indians. While in the vicinity, Lawson wrote one of the earliest descriptions of a bottomland hardwood forest. His diary and observations were later compiled into the classic A New Voyage to Carolina. (© 1967 by the University of North Carolina Press, used by permission of the publisher.)

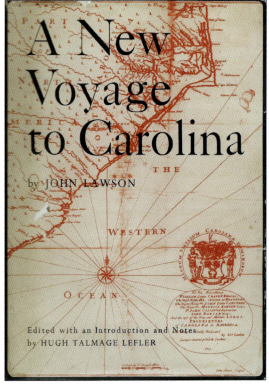

Col. William Thomson was a Revolutionary War hero who resided at Belleville Plantation, near the south bank of the Congaree River in the old Orangeburg District. Thomson was also a successful planter who grew indigo on his holdings on the north bank of the Congaree River in what is now Congaree National Park. He is seen here in a c. 1790 watercolor painting on ivory by Edward Savage. (Courtesy of the Gibbes Museum of Art/Carolina Art Association.)

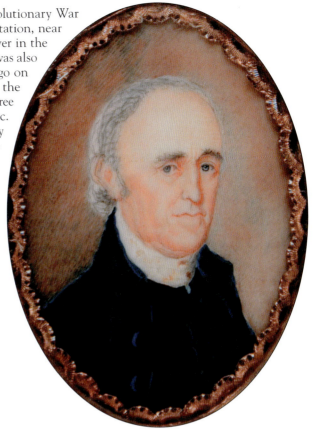

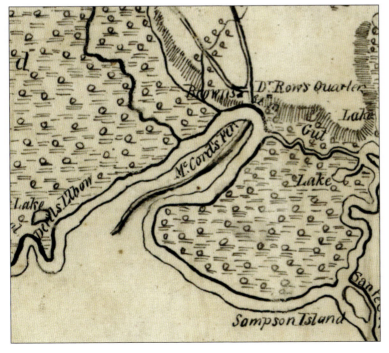

This 1825 map by Robert Mills shows the location of historic McCord's Ferry on the lower Congaree River. During the Revolutionary War, it was a strategic crossing used by both the British and the Patriots. It was here in May 1781 that Gen. Nathanael Greene, leader of the southern Continental Army, first met the "Swamp Fox," Francis Marion. (Courtesy of the Library of Congress.)

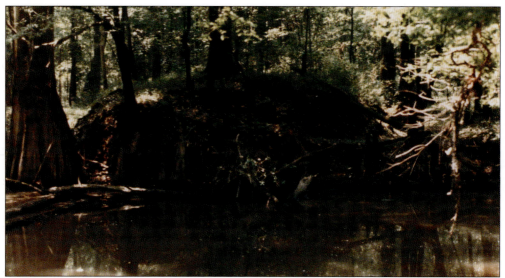

This large mound of earth on the edge of Running Lake in the eastern end of Congaree National Park is the remains of wooden bridge abutment for a road that once led to Huger's Ferry. Gen. Isaac Huger was a Revolutionary War hero who was granted a concession in 1786 by the State of South Carolina to operate a ferry on the lower Congaree River. (Courtesy of the NPS.)

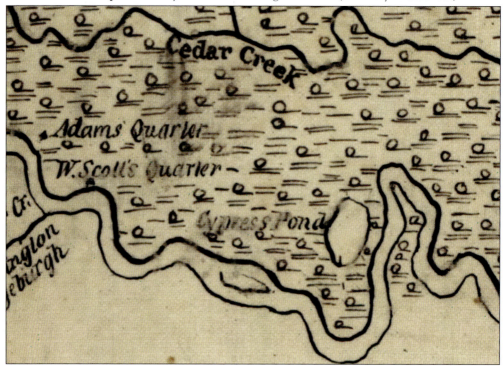

This map from Robert Mills's 1825 atlas shows land that was under cultivation along the north bank of the Congaree River (now within the Congaree National Park), as indicated by "Adams' Quarters" and "W. Scott's Quarters." The quarters housed slaves who worked the fields that were planted in corn, cotton, oats, peas, and other crops. The "Cypress Pond" has filled in over the years and no longer exists. (Courtesy of the Library of Congress.)

This large antebellum agricultural dike, found along the western boundary of the park, was constructed in the 1830s by a slave labor force belonging to James Adams, a prominent lower Richland planter. In his 1841 will, Adams noted that should his children "become unwilling to continue embanking the swamp lands as I have commenced, then, they may sell their interest." (Photograph by John Cely.)

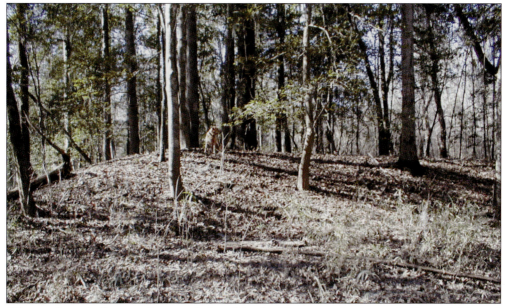

Of several antebellum cattle mounds found in the Congaree, the largest is Cooner's Mound, shown here and measuring 90 feet long, 50 feet wide, and 8 feet high. Bottomland hardwood forests like the Congaree were prime grazing lands for free-ranging cattle and pigs. Mounds were constructed by slave labor to provide temporary refuge for livestock during high water from floods. (Photograph by John Cely.)

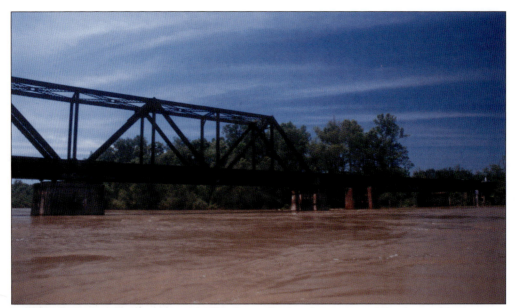

In 1842, the Louisville, Cincinnati & Charleston Railroad constructed the first rail line spur in South Carolina, a line that ran from Branchville to Columbia. Bridging the Congaree River was a difficult undertaking, as was constructing the rail line, built entirely on wooden pilings, across two and a half miles of the Congaree Swamp. The railroad bridge suffered several washouts, fires, and flood damage over the years but has been in continuous operation for 175 years. (Courtesy of the NPS.)

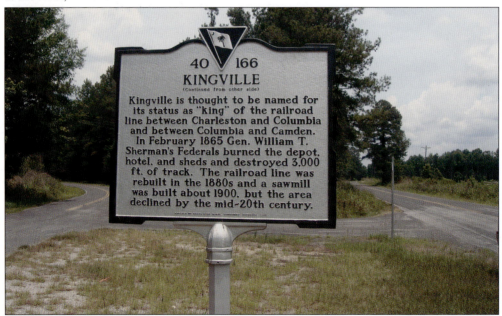

Kingville was first established as a junction in 1848, when the South Carolina Rail Road Company constructed a spur line from the north side of the Congaree Swamp to Camden. On the eve of the Civil War, the junction had grown to include a hotel, post office, shops, offices, and residences. Much of it was destroyed by General Sherman's invading Union army in 1865. Today, nothing remains of Kingville except the railroad junction itself. (Photograph by John Cely.)

The South Carolina Land Commission was established after the Civil War to provide lands for recently freed slaves. One such property, known as the Hunt Tract, was located within the Congaree National Park. It was divided into 21 parcels, only two of which were ever purchased. The red line is the current river channel, while the blue lines are swamp waterways. (© 2009 by the Public History Program, University of South Carolina, for the Lower Richland County African-American Heritage Project.)

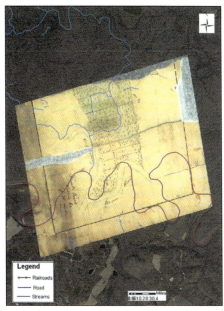

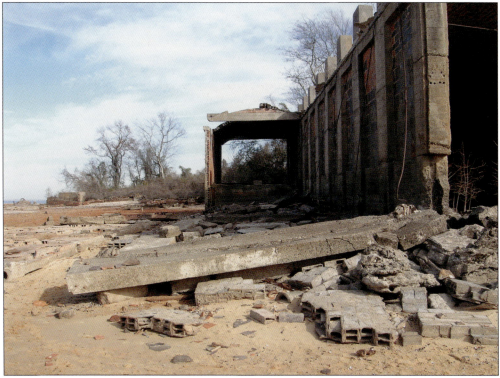

In the late 1800s, the timber industry came south to harvest virgin stands of longleaf pine and bald cypress. The Santee River Cypress Lumber Company, headed up by Francis Beidler I of Chicago, purchased thousands of acres of South Carolina swampland to provide a continuous source of cypress logs for his mill on the Santee River at Ferguson, now under the waters of Lake Marion. The photograph shows part of the old mill high and dry after the 50-year drought of 2007–2008. (Photograph by John Cely.)

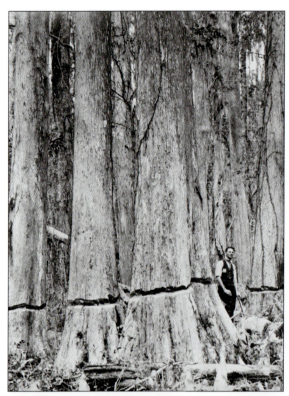

Much of Congaree's virgin cypress was removed by float logging. Before felling, the trees had to first be girdled with an axe and allowed to "cure" on the stump for up to a year, as the cypresses in this old photograph are doing. The cured wood, when cut into 16-foot logs, was light enough to float. Once poled out to the river, the big logs were chained together in a raft and floated downstream to the sawmill. (Courtesy of the NPS.)

Moonshine whiskey was a significant cottage industry in rural South Carolina for much of the 20th century. Congaree Swamp, because of its remoteness and abundant water supply, was a popular location for illegal stills. The author has located nearly a dozen old stills within the park over the past 40 years. (Courtesy of John Grego.)

Two

SAVING THE SWAMP

By 1915, the logging of Congaree's virgin bald cypress stands had come to an end. For the next half-century, the swamp lay dormant and known to only a few local sportsmen who leased it as a hunting and fishing preserve. One such outdoorsman was Harry R.E. Hampton, who first became interested in the 15,000-acre "Beidler Tract," as the old-growth portion of Congaree was called, because of its pure strain of eastern wild turkey. Hampton soon realized that the place had something special besides wary wild turkeys—a rare forest with trees of record-setting proportions. Hampton spent the next 30 years of his life educating the public, community leaders, politicians, and anyone else who would listen about the wonders of Congaree Swamp. In the late 1950s, a National Park Service team he guided through the area strongly recommended that it become part of the national park system. However, since no logging was being conducted at the time, the sense of urgency to protect the area fell mostly on deaf ears, and preservation efforts stalled.

Logging of Congaree's giant hardwoods finally got underway in 1969. In 1973, a citizens' grassroots campaign, led by a young high school biology teacher from Columbia named Jim Elder, renewed efforts to save the swamp. The campaign involved hundreds of ordinary people—college and high school students, housewives, businessmen, schoolchildren, and others—all writing letters, giving presentations, delivering petitions, and making phone calls to their elected representatives. Individual efforts were aided by the collective voices of the Sierra Club, South Carolina Environmental Coalition, Columbia Audubon Society, garden clubs, and other conservation organizations. Federal legislation to protect the park was introduced by Second Congressional District representative Floyd Spence. In the US Senate, the bill was championed by Senators Strom Thurmond and Fritz Hollings. The final hurdle was passed when the owners agreed to sell, and Pres. Gerald Ford signed legislation on October 18, 1976, that created the Congaree Swamp National Monument. Harry Hampton was 79 years old and lived to see a protected Congaree Swamp become a reality.

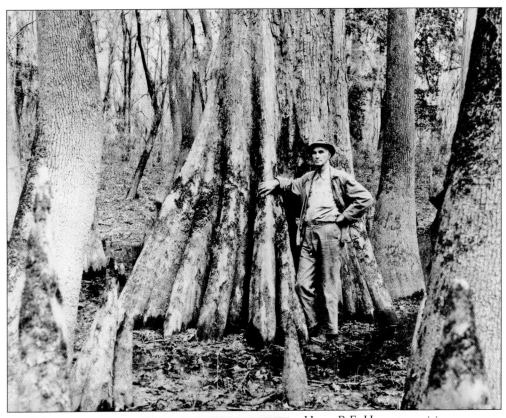

Harry R.E. Hampton, visionary conservationist and outdoorsman, was the first to bring the world's attention to the wonders of Congaree's old-growth bottomland forest and its big trees. The virgin cypress pictured here is more than 23 feet in circumference and, at 132 feet, one of the tallest in the park. (Photograph by Gordon Brown.)

Hampton was a journalist and editor at the *State* newspaper and wrote a long-running weekly outdoor column, "Woods and Waters," which, along with his lectures, letters, and field trips, advocated for the park's protection. (Courtesy of the Hampton family.)

In 1959 and 1961, a study team from the National Park Service visited Congaree. Its findings, released in a 1963 Specific Area Report, concluded with the following: "No other bottomland area in the southeast was found which contains geological and biological significance comparable to the Congaree Swamp. Preservation would be in the national interest." (Courtesy of the NPS.)

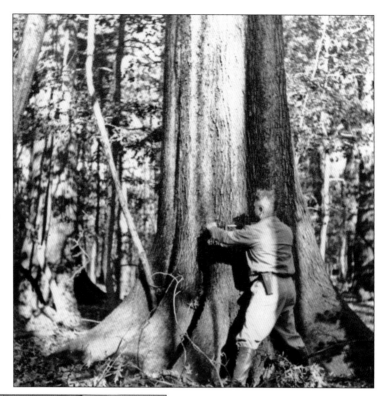

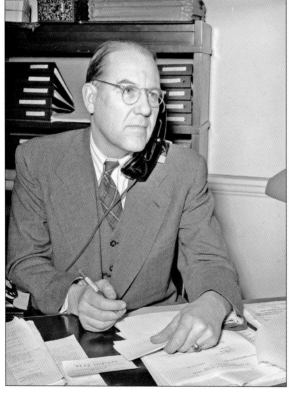

Richard Pough, a founder of the Nature Conservancy and former chairman of conservation and general ecology at the American Museum of Natural History, lent national stature for saving Congaree. Pough stated, "this forest is not only unique but, in my opinion, the finest unprotected forest on the continent." One insider called Pough the "foremost land preservationist of his time." (Courtesy of the American Museum of Natural History Library.)

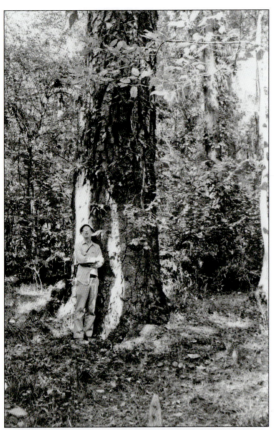

Author and naturalist John V. Dennis of Princess Anne, Maryland, was the first to conduct systematic botanical and ornithological surveys of Congaree's old-growth forest in the 1960s and early 1970s. Dennis was also a dedicated ivory-billed woodpecker searcher who saw the elusive bird in Cuba in the 1940s and east Texas in the 1960s but never found it at Congaree. (Courtesy of the NPS.)

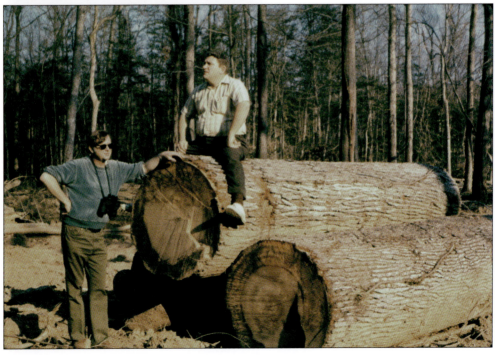

These huge, recently cut Congaree sweetgum logs, nearly four feet in diameter, are destined for the veneer mill. Both large sweetgums and cherrybark oaks were prime targets for the loggers when cutting began in Congaree's Beidler Tract in 1969. (Courtesy of the NPS.)

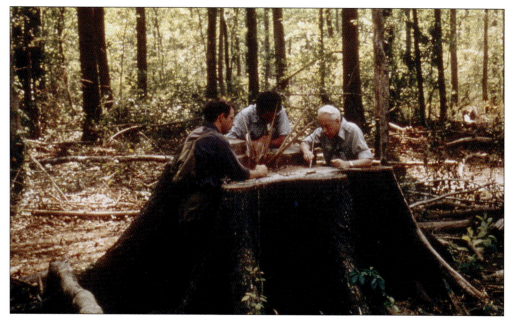

From left to right, John Cely, Jim Elder, and James Tanner examine the growth rings of a recently cut cherrybark oak in April 1974. As a graduate student at Cornell in the 1930s, Dr. Tanner conducted the only in-depth study ever of the ivory-billed woodpecker, in the old-growth 80,000-acre Singer Tract in northeastern Louisiana. Tanner stated that, except for its smaller size, the Congaree reminded him of the Singer Tract. (Courtesy of Richard Watkins.)

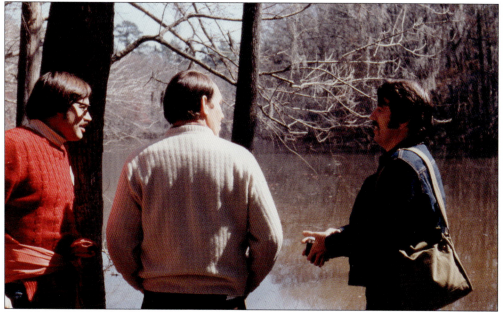

The National Park Service came back to Congaree in February 1974 as the new campaign to save the swamp was being unveiled. Having a discussion here at Weston Lake are, from left to right, Brock Evans, head of the Sierra Club's Washington office; Ron Walker, director of the National Park Service; and Gary Soucie, field editor for *Audubon* magazine. Evans played a big role protecting Congaree at the national level. (Courtesy of the NPS.)

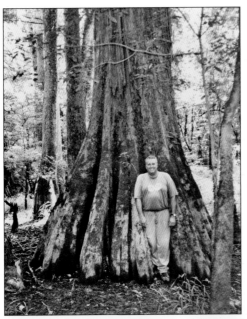

Jim Elder, a high school biology teacher from Columbia, spearheaded the citizens' campaign from 1973 to 1976 that protected Congaree Swamp. It was a true grassroots effort that involved hundreds of ordinary people from all walks of life who just wanted to do something to help. Here, Elder poses, appropriately, in front of the Harry Hampton bald cypress some 20 years after the park was established. (Courtesy of the NPS.)

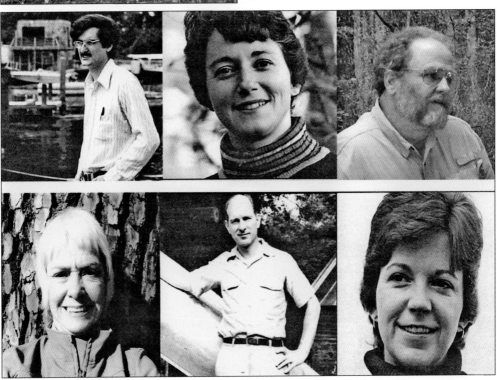

Some other Congaree activists were, from left to right, (top row) Brion Blackwelder, Ann Jennings, and Steve Collum; (bottom row) Ann Timberlake, Ted Snyder, and LaBruce Alexander. A number of Congaree activists went on to make careers in conservation and environmental protection. (Brion Blackwelder, Ann Jennings, Ted Snyder, and LaBruce Alexander courtesy of *South Carolina Wildlife* magazine; Steve Collum courtesy of John Grego; Ann Timberlake courtesy of Ann Timberlake.)

George Taylor was one of many high school students involved in saving the Congaree. Taylor was a gifted photographer who specialized in taking black-and-white images and wide-angle shots of the swamp. His photographs were used in campaign brochures, flyers, and the slideshow to save the swamp. (Courtesy of the NPS.)

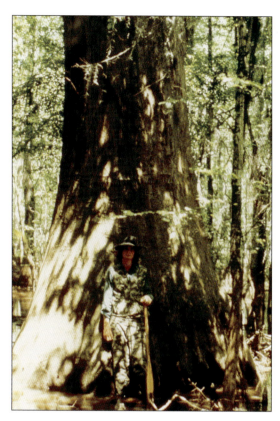

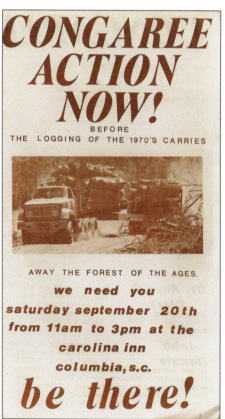

The campaign to save the swamp was organized as the Congaree Swamp National Preserve Association. It was aided by the Sierra Club, the South Carolina Environmental Coalition, the Columbia Audubon Society, and other conservation organizations. The campaign culminated with Congaree Action Now, a massive, day-long rally of more than 700 people (the largest gathering of conservationists in the state's history), held in Columbia on September 20, 1975. (Courtesy of George Taylor.)

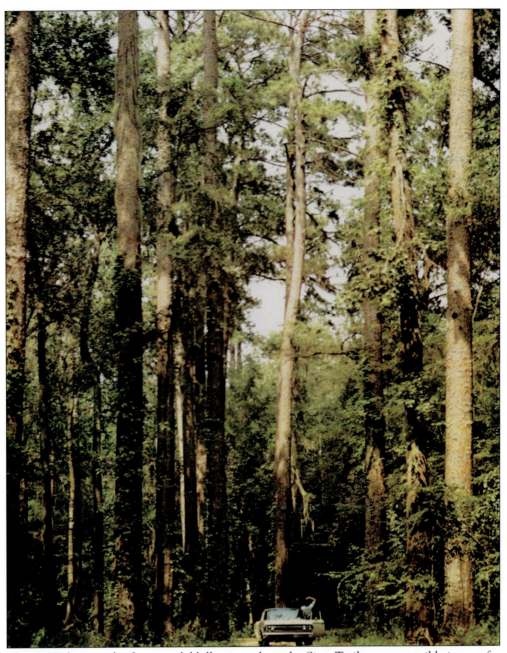

This 1975 photograph of ancient loblolly pines along the Sims Trail was responsible in part for Congaree being dubbed "Redwoods of the East" during the campaign to spare it from logging. Unfortunately, a pine bark beetle infestation in the early 1980s killed many of these giants, and Hurricane Hugo finished off more of the survivors in 1989. Fortunately, there are many large pines still standing in the park, including the national champion. (Courtesy of George Taylor.)

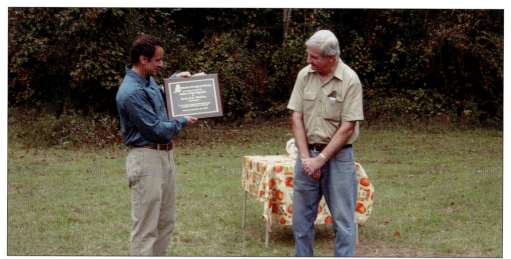

Richard Watkins was instrumental in the 1970s campaign to protect Congaree Swamp and has been a dedicated advocate for the park ever since. Here, Watkins (right) is awarded the Order of the Cypress by Friends of Congaree Swamp president John Grego in 2010. Watkins was also recognized for his work on behalf of the Congaree when he received the 2003 Marjory Stoneman Douglas Award from the National Parks Conservation Association. (Photograph by John Cely.)

Larry and Nancy Turner displayed the enthusiasm and dedication common among Congaree advocates of the 1970s. They started out answering phone calls, stuffing envelopes, doing presentations, then making strategy and planning the Congaree Action Now rally. They were also part of an organized two-bus team that traveled to Washington in April 1976 to lobby Congress for action on a bill to protect Congaree. This photograph was taken in 2009 at a reunion of Congaree activists. (Courtesy of John Grego.)

A Congaree slideshow was one of the most important tools of the Save the Swamp campaign. Twenty-seven sets were produced and, along with a script, mailed out to hundreds of garden clubs, civic clubs, professional organizations, and other groups that needed a program. Here, Margot High demonstrates her shipping method of packing slides in recycled milk cartons at a 2009 Congaree campaign reunion. (Courtesy of John Grego.)

Robert Janiskee, emeritus distinguished professor of geography, taught for 33 years at the University of South Carolina and was involved in the early stages of the campaign to protect Congaree. His lifelong interest in national parks includes travel, writing, and teaching classes about them. He is on the Board of Directors of National Parks Traveler, a 501(c)(3) nonprofit organization, and has been for many years a contributing editor for their webzine. (Courtesy of Robert Janiskee.)

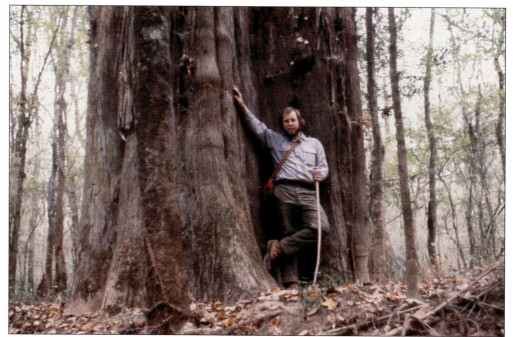

Biologist L.L. Gaddy has spent more than 40 years conducting research at Congaree National Park. He was the senior author in a 1975 study commissioned by the South Carolina Department of Natural Resources that convinced many state leaders that Congaree's unique values were in jeopardy and required prompt action to save them. His most recent contribution about the park is a book, *The Natural History of Congaree Swamp*. (Courtesy of the NPS.)

Senators Walter Bristow (left) and Hyman Rubin were champions of the Congaree in the South Carolina General Assembly during the crucial period when Congress was debating its protection in 1976. Their efforts included a three-day filibuster to counter opposition to the park within the senate. Both were recognized years later for their support of the park when the Friends of Congaree Swamp presented them with the Order of the Cypress award in 1999. (Photograph by John Cely.)

On the South Carolina House side, Rep. Bill Campbell of Columbia was a staunch advocate for the park. Campbell made a special trip to Washington to let Congress know that South Carolinians wanted Congaree National Park. Here, Campbell (right) receives the South Carolina Wildlife Federation's 1975 Conservationist of the Year award from South Carolina governor James B. Edwards. (Courtesy of the South Carolina Wildlife Federation.)

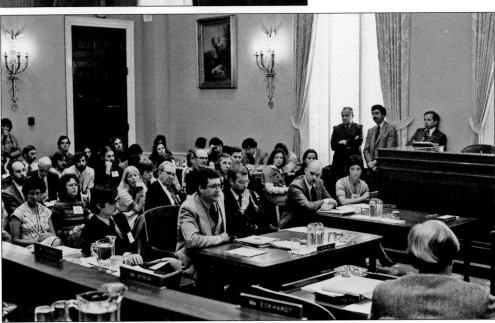

Conservationists testify at a congressional hearing in April 1976 in support of a bill to establish the Congaree Swamp National Monument. Seated at the tables are, from left to right, Jim Elder, Gerry Hutchinson, Ed Easton, and Ann Jennings. Brion Blackwelder is to the right of Elder behind the water pitcher. (Courtesy of Steve Collum.)

Three

PARK BEGINNINGS

Even though logging had stopped and the Congaree Swamp National Monument was now part of the national park system (at least on paper), it remained a daunting task to build a park from scratch. A superintendent and staff had to be hired, boundaries marked and patrolled, and the necessary facilities and infrastructure put in place to support pubic visitation. For the first few years, park headquarters was located in the Strom Thurmond Federal Building in downtown Columbia. Federal legislation that had authorized the park allowed the hunting lease that came with the property to remain in effect until the end of 1982 (an interesting situation where during the hunting season, park rangers had to first consult the lease holder before conducting nature walks). It was not actually until January 1, 1983, that the park was able to fully open its doors to unlimited public access.

As might be expected, attendance started out slowly for the first few years of the park's existence, with only a few thousand visitors annually. But gradually the word got out that the Congaree Swamp National Monument was open for business, and visitor use picked up. From its inception, the park was popular with school groups and classes. Construction of an elevated boardwalk in 1985 allowed easy access for visitors to the interior of the park, and a visitor center and ranger station provided facilities and public contact. The trail system of more than 30 miles was put in place, canoe trails were cleared, and more programs were offered to the public. The public was also discovering Congaree's recreational opportunities, including hiking, fishing, camping, canoeing, birding, photography, and nature study.

In 1983, Congaree was recognized as an international biosphere reserve, and in 1988, over two-thirds of the 15,000-acre national monument was designated as official wilderness under the National Wilderness Preservation System. But at the dawn of a new century, Congaree was starting to experience growing pains. Its size had grown to nearly 20,000 acres, and facilities were constrained by increased visitation. One of the biggest issues was the fact that the dirt entrance road did not belong to the National Park Service!

The park was first created in 1976 as the Congaree Swamp National Monument. (Courtesy of the NPS.)

Robert McDaniel was Congaree's first superintendent, serving from 1978 to 1995. His job was to build a park from scratch, a difficult undertaking. This included the construction of basic facilities and infrastructure, hiring of personnel, and making the park known to the surrounding community and the rest of the world. (Courtesy of the NPS.)

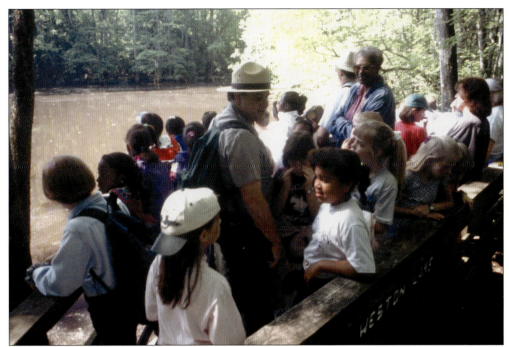

Park ranger Fran Rametta was Congaree's "Mr. Ambassador" for 30 years. As chief of interpretation, Rametta was responsible for introducing the wonders of Congaree to a whole generation of adults and children. His "Owl Prowls" were one of the park's most popular programs. (Courtesy of the NPS.)

Ranger Guy Taylor was the first law enforcement officer assigned to Congaree. He was a natural fit for the job and brought to the position a lifetime of woods knowledge and outdoor experience. Fran Rametta considered him the finest woodsman he had ever seen. (Courtesy of the NPS.)

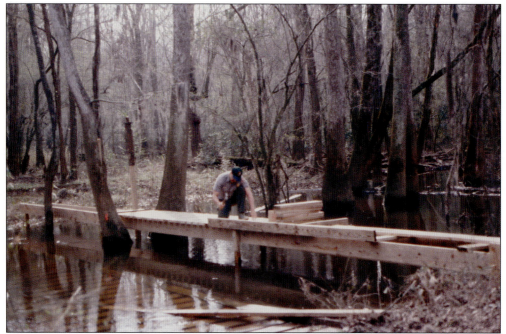

When Rametta came on board in 1980, the park existed mainly on paper. He and ranger Guy Taylor had to do it all, including laying out the trail system, constructing footbridges and boardwalks, conducting patrols, and providing routine maintenance and repair, in addition to educating the public about Congaree's values. (Courtesy of the NPS.)

Booker Sims was one of the first maintenance employees hired by the park. He grew up on the edge of Congaree Swamp and fished its creeks and lakes as a youngster. The Sims Trail is named in his honor. (Courtesy of the NPS.)

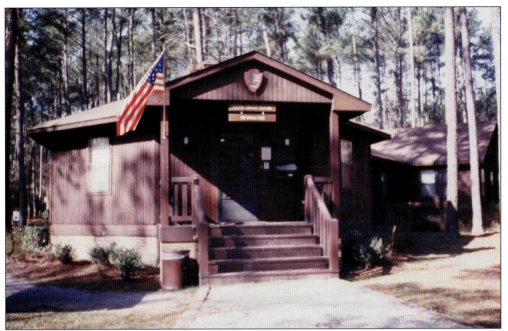

Congaree's first ranger station and visitor center was constructed in 1985. Office space for the superintendent and staff was added to the rear of the building in 1989. It did not take long to outgrow the limited space, but it did take another 12 years before a larger and much-improved building was constructed. (Courtesy of the NPS.)

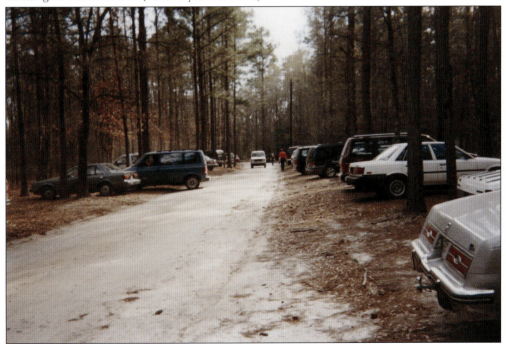

Visitor parking during the early days of the park was informal and consisted of parking under the trees, on the side of the road, or anywhere one could find a space. Visitation hours were from dawn till dusk. (Courtesy of the NPS.)

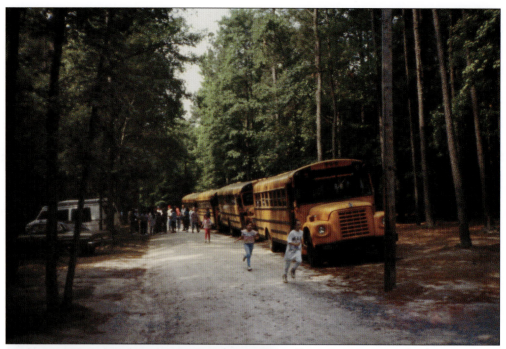

Congaree was a popular destination for school outings and field trips. School visitation occurred mostly in the spring. (Courtesy of the NPS.)

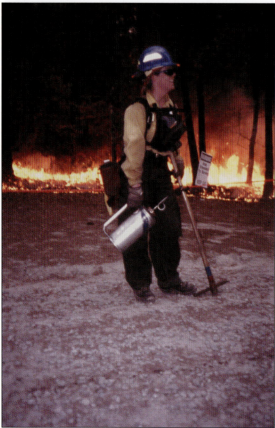

In 1984, the park began a prescribed fire management program for the pine-dominated uplands bordering the swamp. In addition to reducing fuel loads and averting catastrophic wildfires, the controlled burns were done for longleaf pine restoration and to maintain habitat for a small group of endangered red-cockaded woodpeckers barely holding on in the park. (Courtesy of the NPS.)

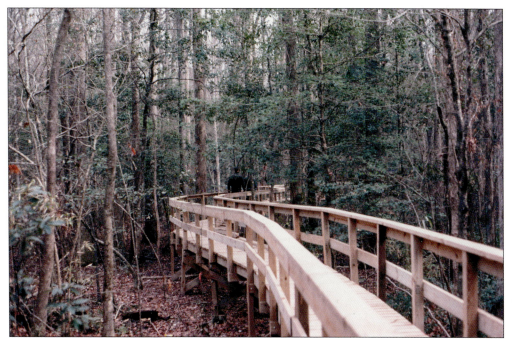

An elevated 3,600-foot boardwalk was erected in 1985 to provide park visitors easy access to the interior of the Congaree floodplain all the way to Weston Lake. Construction of the boardwalk relied heavily on volunteers, Jobs Bill workers, Youth Conservation Corps members, and park employees. (Courtesy of the NPS.)

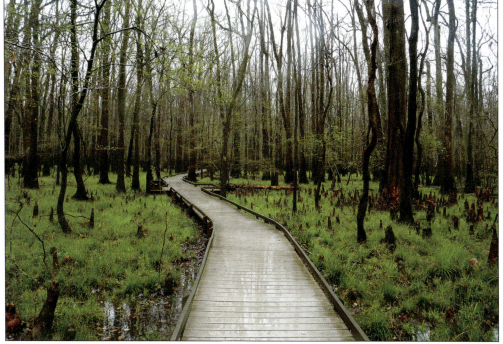

A low boardwalk was constructed in 1990 that connected to the elevated boardwalk and created a 2.4-mile boardwalk loop. (Courtesy of John Grego.)

The park's entrance drive for 20 years was a private dirt road that actually belonged to the surrounding community outside of the park. (Courtesy of the NPS.)

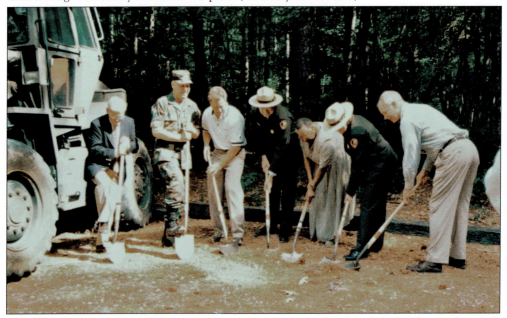

Ground-breaking for the new park entrance road in 1998 includes, from left to right, unidentified, South Carolina adjutant general Stanhope Spears, Gov. David Beasley, Southeast Region associate regional director for planning Tom Brown, Richland County councilwoman Bernice Scott, Congaree Swamp National Monument superintendent Martha Bogle, and River Alliance chairman Mike Dawson. The innovative governmental partnership that constructed the road and the new visitor center resulted in a substantial savings in construction costs for the National Park Service. (Courtesy of the NPS.)

In 1988, much of Congaree National Park was designated as official wilderness under the National Wilderness Preservation System. Currently, the park has about 22,000 acres of wilderness, one of the largest amounts anywhere in the country so close to a large population center. (Photograph by John Cely.)

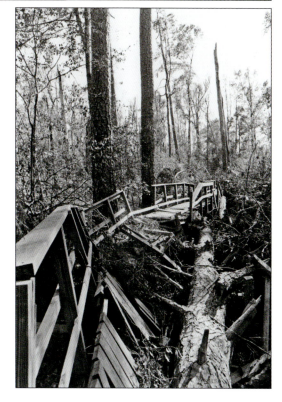

Hurricane Hugo, a Category 4 storm, was probably the most significant natural event of the 20th century to affect Congaree. The eye of the storm passed 15 miles east of the park on the night of September 21–22, 1989, with sustained wind gusts of 90 miles per hour. Many large trees were blown down or snapped off. The entire elevated boardwalk, pictured here, was destroyed, and the park was closed for more than two weeks. (Courtesy of the NPS.)

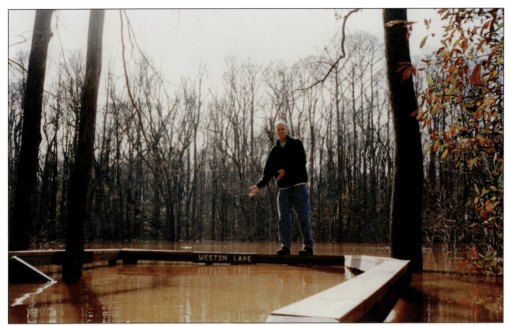

A flood of this magnitude, when even the high boardwalk is underwater, occurs every few years, usually in late winter and early spring. The entire Congaree floodplain, two and a half to three and a half miles wide, is then under a heavy sheet flow of water six to eight feet deep. Flooding is caused by heavy rains in the park's 14,000-square-mile watershed, which is larger than the state of Maryland and extends all the way into western North Carolina. (Courtesy of the NPS.)

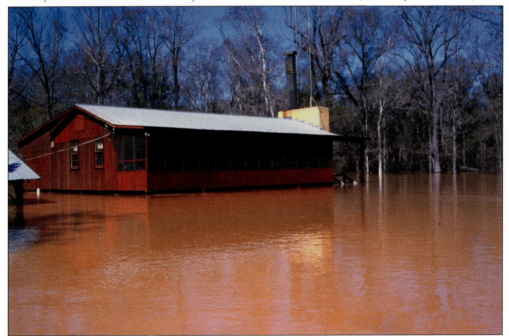

This flood photograph shows the old hunt cabin with water almost up to its flooring. The cabin, located on the edge of Cedar Creek at the end of the Sims Trail, sat on six-foot pilings. It was later demolished due to structural damage and decay. (Courtesy of the NPS.)

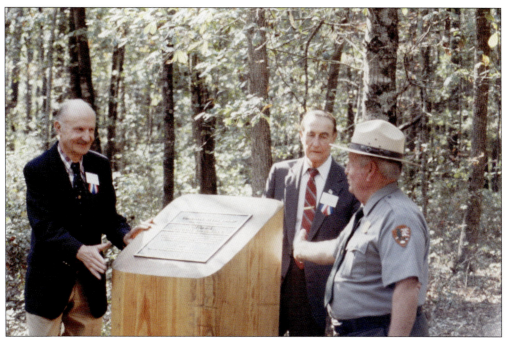

This 1991 photograph shows the dedication ceremony celebrating the 15th anniversary of Congaree Swamp National Monument and the 75th anniversary of the National Park Service. From left to right are Wade Batson, professor of botany, University of South Carolina; US senator Strom Thurmond; and Congaree National Park superintendent Robert McDaniel. Dr. Batson's legendary field trips often included the Congaree even before it was a park. (Courtesy of the NPS.)

Martha Bogle was Congaree's superintendent from 1995 to 2005. During her tenure, the park underwent its most dramatic transformation, including the construction of a new paved access road and the Harry Hampton Visitor Center. She was also superintendent when the Congaree Swamp National Monument was renamed Congaree National Park and when the Old-Growth Bottomland Forest Research and Education Center was established at the park. (Courtesy of the NPS.)

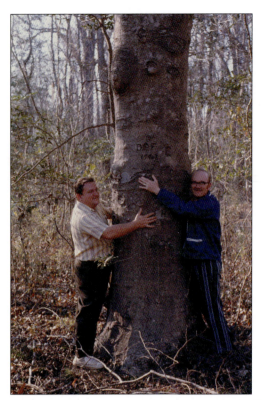

The former national champion American holly tree was one of a dozen national champion trees—the biggest of their kind—located in the park during its early beginnings. It was more than eight feet in circumference and 95 feet tall, an incredible size for what is normally a moderate understory tree. Like many Congaree champions, the holly finally succumbed to a wind storm. (Courtesy of the NPS.)

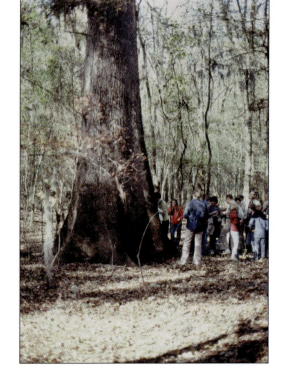

Congaree's national champion overcup oak from the 1970s was 21 feet in circumference. The park does not advertise locations or provide signage for its champion trees. (Courtesy of the NPS.)

Four

A New Century for the Park

At the start of the new millennium, the Congaree Swamp National Monument was not quite 25 years old and still a small and relatively little-known unit of the national park system. But big changes were coming, beginning with a new paved entrance road and a 12,000-square-foot visitor center named for Harry Hampton. These badly needed improvements were made possible because of an innovative partnership with the Army and Air National Guard civil engineering units from across the country, the South Carolina Military Department, the Richland County Legislative Delegation, Richland County Council, and the River Alliance. This unique partnership saved the National Park Service millions of dollars in construction costs.

On November 10, 2003, Congaree became the nation's newest and 57th national park. The name change reflected the park's exceptional biodiversity and geologic features as well as its cultural and historical resources. Park acreage, purchased from willing sellers, had been steadily increasing during the first two decades of the 21st century so that, by 2016, park size was 26,539 acres, an 80-percent increase over its original 15,000 acres. Annual visitation for 2016 was a record-breaking 143,843 people.

More kudos came to the park with it being designated a globally important bird area in 2001 and a Ramsar Wetland of International Importance in 2012. In 2004, the Old-Growth Bottomland Forest Research and Education Center was established at Congaree to facilitate research and encourage science-based education.

With the park's growth, improved facilities, and new outreach programs came the realization that, like parks everywhere, Congaree is vulnerable to threats as never before. The 14,000-square-mile watershed that feeds into the park carries pollutants and excess sedimentation. Invasive, nonnative plants have become established in the park, and feral swine damage native flora and fauna. Exotic insects with the ability to wipe out an entire tree species are on the park's doorsteps, and rapid climate change threatens the park's basic ecological processes. Congaree has taken steps to mitigate some of these problems, but resolving others will require the same broad base of support from an informed and active citizenry that it took to establish the park. It also underscores what conservationists have known all along, that protecting a national park is a continuous undertaking that never really ends.

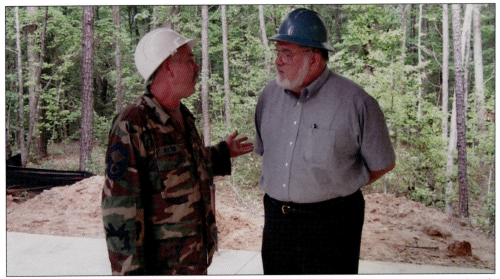

S.M.Sgt. Carland Allen, project leader, and architect John Watkins discuss construction details for Congaree's new visitor center, to be named for Harry Hampton. The special partnership between the National Park Service and the South Carolina Military Department, including the Army and Air National Guard, along with the River Alliance, the Richland County Legislative Delegation, and Richland County Council, was unique within the national park system. (Courtesy of the NPS.)

National Guard engineering units from across the nation spent their annual two-week training exercise constructing the new visitor center, entrance road, and parking lots. All told, these citizen-soldiers donated more than 75,000 hours of skilled labor and saved the National Park Service millions of dollars in construction costs. As superintendent Martha Bogle later said, "It was a great marriage of minds, talents, and passion with incredible synergy and wonderful results. Quite frankly it had never been done before." (Courtesy of the NPS.)

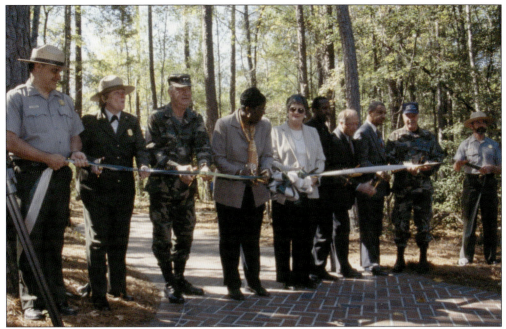

The Harry Hampton Visitor Center opened in early 2001. Attending the ribbon-cutting ceremony are, from left to right, ranger Fran Rametta, superintendent Martha Bogle, Maj. Gen. Stanhope Spears of the South Carolina Military Department, Richland County councilmember Bernice Scott, Harriott Faucette (daughter of Harry Hampton), two unidentified, National Park Service Southeastern Region director Jerry Belson, S.M.Sgt. Carland Allen, and ranger John Rich. (Courtesy of the NPS.)

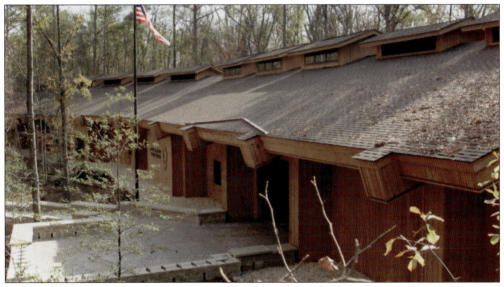

The new visitor center was built in a woodland setting on the edge of a bluff overlooking the Congaree floodplain. Along with staff office space, it features spacious exhibition displays, an auditorium for showing the park video, a book and museum shop, a life-size replica of a towering bald cypress, and a magnificent 75-foot mural by South Carolina artist Blue Sky. (Courtesy of the NPS.)

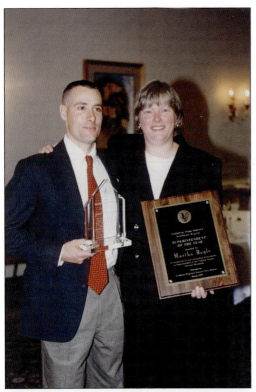

Chief of maintenance Lewis Prettyman and superintendent Martha Bogle receive Employee of the Year and Superintendent of the Year for the Southeastern Region for their role in partnering with the National Guard for construction of the new entrance road and the Harry Hampton Visitor Center. This was the first time two employees from the same park received this recognition. (Courtesy of the NPS.)

Much of the maintenance and repair work to keep the park's trails, bridges, and boardwalks safe and secure for visitors falls on the shoulders of John Torrence. Here, Torrence takes a break from a work detail to enjoy a spring crop of butterweed. (Courtesy of the NPS.)

For the park's first 27 years, it was known as the Congaree Swamp National Monument. In November 2003, the name was changed by Congress to Congaree National Park to reflect the park's extraordinary diversity and rich cultural and historical features. (Courtesy of Rhonda Grego.)

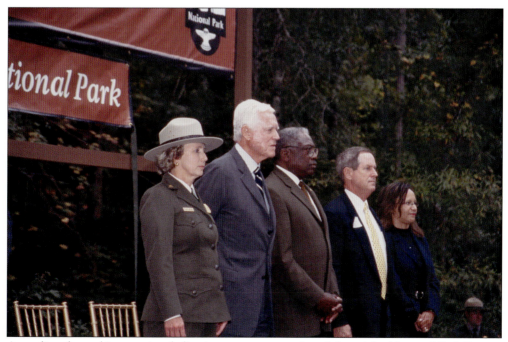

Attending the park's renaming dedication ceremony are, from left to right, National Park Service director Fran Mainella, US senator Fritz Hollings, Sixth Congressional District congressman James Clyburn, Second Congressional District congressman Joe Wilson, and National Park Service Southeast Region director Pat Hooks. (Courtesy of the NPS.)

Tracy Swartout was Congaree's third superintendent, serving from 2006 to 2012. A Columbia native, Swartout emphasized outreach with the lower Richland community and being involved with development issues that could affect the park. Her proudest accomplishment was to set in place the acquisition of more than 2,000 acres at the park's east end, an achievement that connected all the park's parcels together into one 28-mile stretch along the Congaree River. (Courtesy of the NPS.)

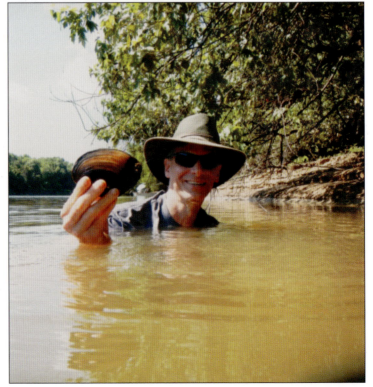

Frank Henning, director of Congaree's Old-Growth Bottomland Forest Research and Education Center, shows off a yellow lampmussel while conducting a freshwater mussel survey on the Congaree River. The center was established in 2004 to provide science-based outdoor education for youth and to encourage and facilitate research on floodplain ecology. (Courtesy of the NPS.)

J. Tracy Stakely became Congaree's fourth superintendent in January 2013. Some of Stakely's goals include hands-on involvement with the local community, increased emphasis on the park's cultural resources, focusing on the park's wilderness values, and improving recreational opportunities for the park's visitors. (Courtesy of the NPS.)

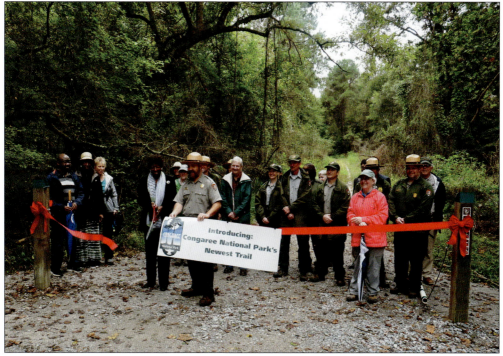

In 2015, the park dedicated its newest trail, the one-mile Bates Ferry Trail (just west of US Highway 601), which goes all the way to the Congaree River. Doing the ribbon cutting is Eastover mayor Earlene Robinson, while park superintendent Tracy Stakely is holding the ribbon. (Courtesy of John Grego.)

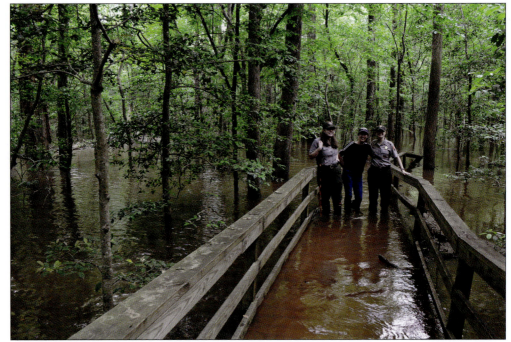

These park rangers do not seem to mind the fact that the elevated boardwalk is underwater from significant flooding in May 2013. (Courtesy of John Grego.)

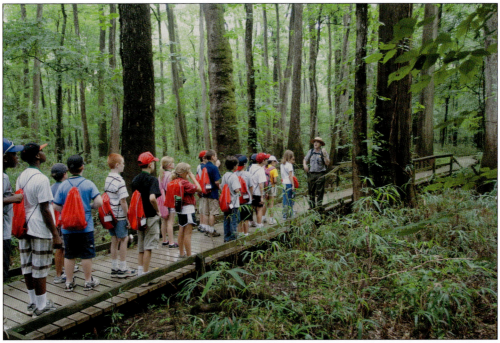

Education coordinator David Shelley of Congaree's Old-Growth Bottomland Forest Research and Education Center discusses Congaree ecology with youngsters on the low boardwalk. (Photograph by Steven McNamara, courtesy of NPS.)

Five

Natural History

The Congaree National Park floodplain is an ever-changing "work in progress" due to the big, restless rivers that meander across its surface. Several oxbow lakes, so named because of their U-shaped, oxen-yolk appearance, indicate changes in the course of the Congaree River only within the past few hundred years. And on the lower Wateree River, an oxbow lake within park boundaries is currently in the process of being created. Scattered throughout the floodplain are clearly defined sloughs, creeks, and backwaters that represent former river channels and oxbow lakes, some dating back 15,000 years or more to the last Ice Age. Congaree's dynamic geology directly influences the park's biota—the distribution and abundance of its plants and animals.

And what biota it is! Congaree is one of the most diverse parks in the national park system, including more than 600 species of plants, 200 species of birds, 35 species of mammals, 60 species of reptiles and amphibians, 60 fishes, and an untold number of invertebrates—insects, spiders, worms, snails, millipedes, crayfish, bivalve mollusks, and other animals without backbones. The park's nonvascular flora—its mosses and algae, as well as its mushrooms, fungi, and lichens—are poorly known, and some are no doubt new to science.

Due to an abundant supply of dead and dying wood, Congaree's old-growth forest features some of the highest numbers anywhere of owls, woodpeckers, and other wildlife that rely on such wood. The crow-sized pileated woodpecker is frequently visible from the boardwalk, and barred owls can be heard, and sometimes seen, during daylight hours. In winter, it appears that every robin in eastern North America is feeding on Congaree's bountiful holly berry crop. In warm weather, the visitor is greeted by an abundance of sights and sounds—the high, zipping call of northern parula warblers from the canopy, a zebra swallowtail butterfly flitting by on silvery wings, the loud call of cicadas and the trill of gray tree frogs, a glimpse of a deer lurking in the switch cane. The park changes dramatically by the seasons, but no matter what time of year, there is always something exciting to see and discover.

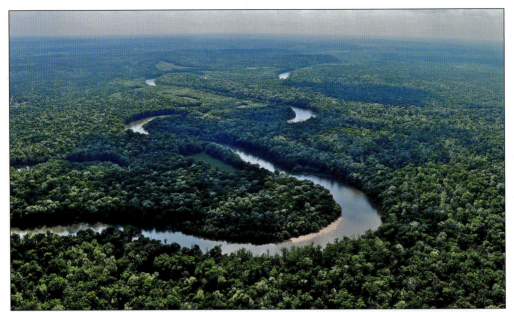

The sinuous, winding course of the Congaree River is clearly evident in this photograph taken over the park from a small plane (the view is northwest towards Columbia). The immensity of the Congaree floodplain is also apparent. (Courtesy of Steve Pittman.)

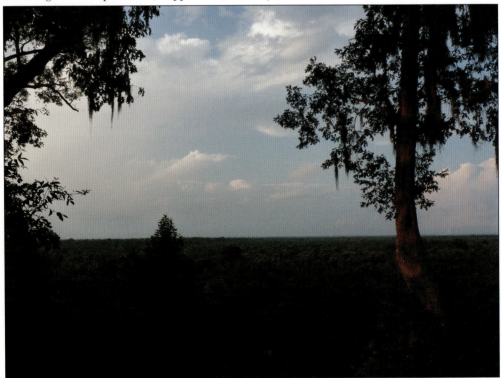

The tall, dense forest canopy of Congaree National Park seems to roll on forever, as shown in this view taken from Congaree Bluffs Heritage Preserve, on the south bank of the Congaree River and 150 feet higher in elevation than the park. (Courtesy of Caroline Grego.)

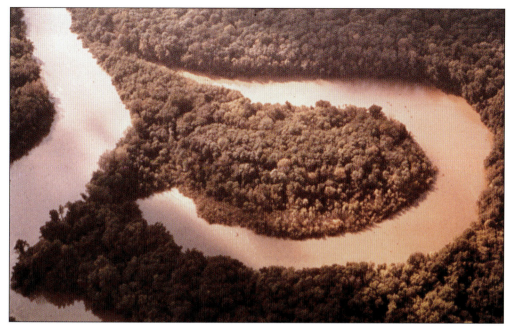

Devil's Elbow, shown here, was until the early 20th century part of the main channel of the Congaree River. It has since become an oxbow lake, created when a major flood bypassed it and opened up a new channel. Oxbow lakes are a common feature of coastal river floodplains, and Congaree National Park contains several, the largest being Bates Old River near US Highway 601. (Courtesy of the NPS.)

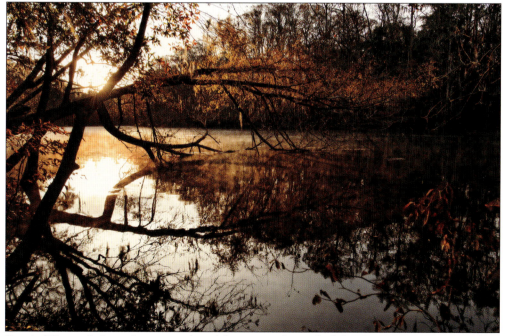

Scenic Weston Lake, a five-acre oxbow lake, was a channel of the Congaree River more than 2,800 years ago. The lake is unusually deep, averaging 14 feet, with one spot being nearly 25 feet. (Courtesy of jt-FINEart.com.)

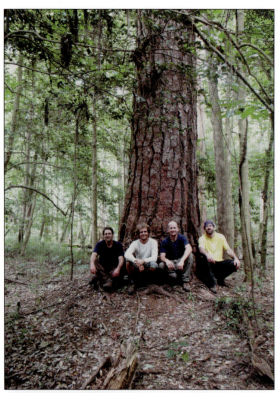

Members of the Native Tree Society (NTS) pose for a photo opportunity before preparing to climb and measure Congaree's national champion loblolly pine, the biggest of its kind. From left to right are Jason Childs, Max ?, Mike Riley, and Will Blozan. The champ is known as the "Riddle Pine" in honor of Jess Riddle, who first found and nominated the tree in 2001. Congaree National Park contains the largest number of ancient loblolly pines in the world. (Courtesy of Stuart Greeter.)

NTS researcher Will Blozan pauses before pushing on to the top of the national champion loblolly pine. Blozan has climbed the tree several times to measure its precise height using a tape drop. In 2010, the tree was 171.2 feet tall. He and his colleagues have also measured the total volume of the tree, which at 1,980 cubic feet of wood is greater than any other species of pine in the East. (Courtesy of Robert Van Pelt.)

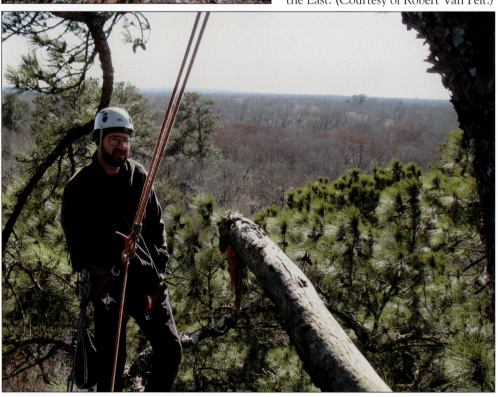

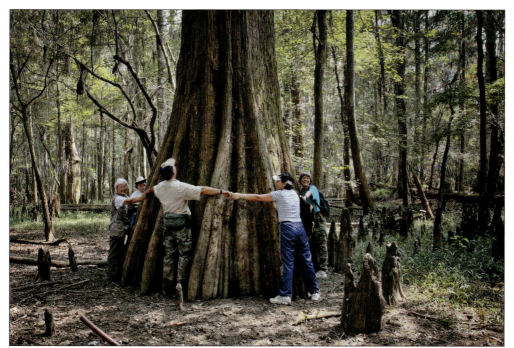

These tree huggers are getting a close look at Congaree's state champion bald cypress, nearly 27 feet in circumference and 125 feet tall. A fair number of virgin cypresses in the park escaped the cutting of the early 20th century because they were hollow, crooked, or had other defects, but others, such as this champion, appear perfectly sound. Some of Congaree's virgin cypresses could be over a thousand years old. (Courtesy of Joe Kegley.)

"Walking maples" are created when red maple seeds germinate in the tops of rotten cypress stumps. As the maple tree grows, it extends its root system around the stump and into the ground. When the stump finally disintegrates, it leaves behind a maple "walking" on its roots. (Courtesy of Leo Rose.)

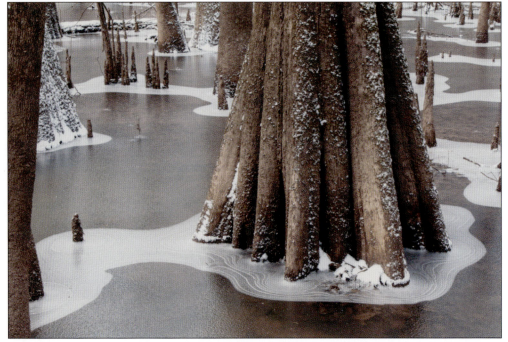

Snow and ice are infrequent events during Congaree winters, but when they do occur, they make for interesting patterns and designs in frozen backwaters and sloughs. (Courtesy of Jerry Bright.)

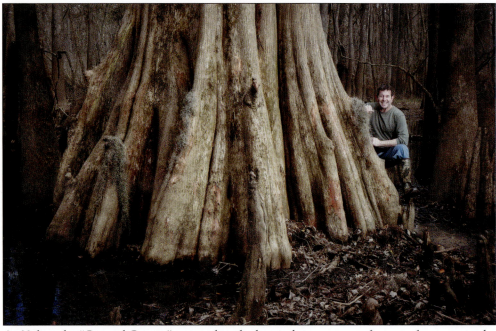

At 29 feet, the "General Greene" cypress has the largest known circumference of any tree in the park. Like many virgin cypresses, the top has been blown out by countless wind storms over the centuries, precluding it from becoming a champion. The tree is named in honor of Revolutionary War hero Nathanael Greene, who first met Francis Marion, the "Swamp Fox," near here in May 1781. (Courtesy of Joe Kegley.)

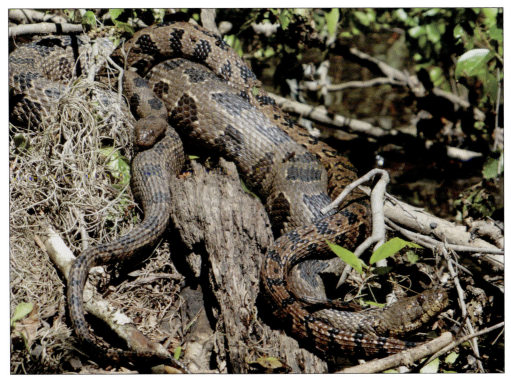

The nonvenomous brown water snake can be seen in warm weather basking on logs, debris piles, and overhanging shrubbery along Cedar Creek. At first blush, it resembles the poisonous cottonmouth or water moccasin, but the markings are different, and it lacks the pronounced triangular head of the cottonmouth. Water snakes can get large and stout, especially after just consuming a meal, as illustrated in this photograph. (Photograph by John Cely.)

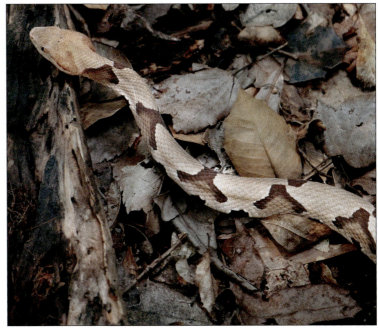

The venomous copperhead is relatively uncommon in the park. It is found in a variety of habitats but generally prefers the higher, better-drained sites. As the photograph shows, it is a master of camouflage. (Photograph by Ted Schantz, courtesy of the NPS.)

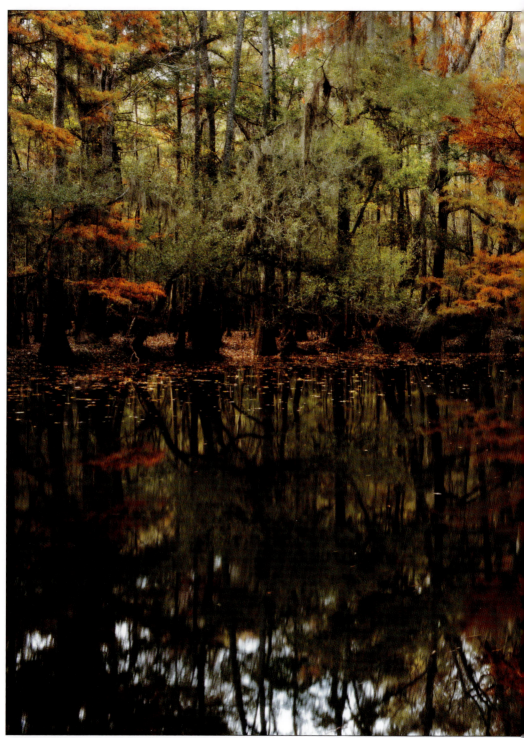

Cedar Creek is the park's primary water artery and canoe trail. It winds through the park for 15 miles before emptying into the Congaree River at Mazyck's Cut. With origins in the sand hills of Fort Jackson, the creek is a black-water stream unless high water from the Congaree River turns

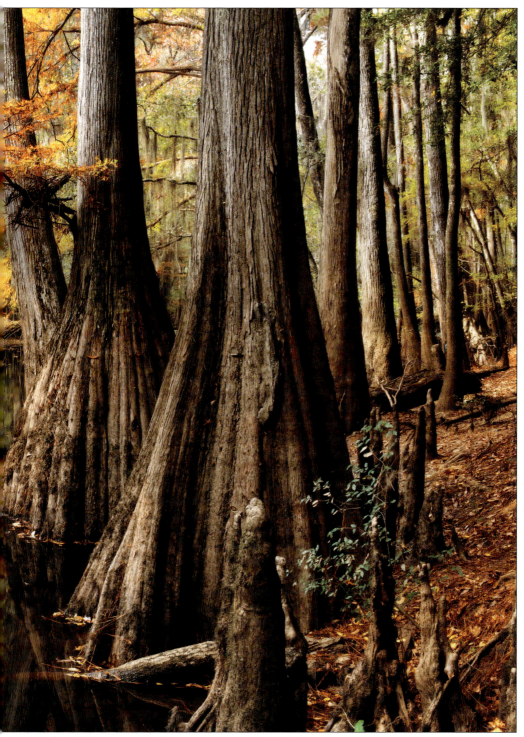

it muddy. Fall is an especially scenic time to paddle its quiet waters, as shown here. (Courtesy of jt-FINEart.com.)

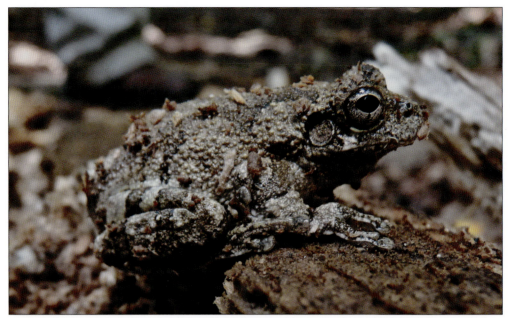

Congaree has an abundant amphibian population of frogs, toads, and salamanders (including aquatic salamanders such as dwarf waterdogs, lesser and greater sirens, and amphiumas). This Cope's gray tree frog has only just recently emerged from its underground hideaway, as the fresh particles of soil still clinging to its skin testify. (Courtesy of John Grego.)

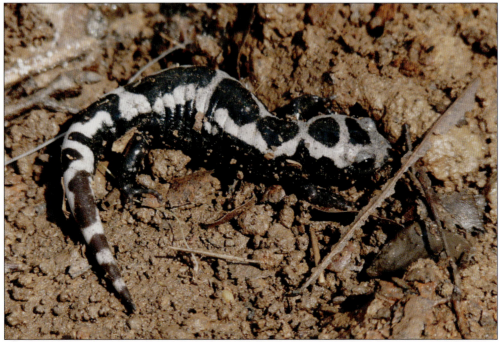

The attractive black-and-white marbled salamander is one of the most common amphibians in the park. They are often encountered under logs in the fall and early winter when they breed. The female typically guards her eggs until they hatch, at which time the larvae continue their development in temporary pools created by winter rains. (Courtesy of John Grego.)

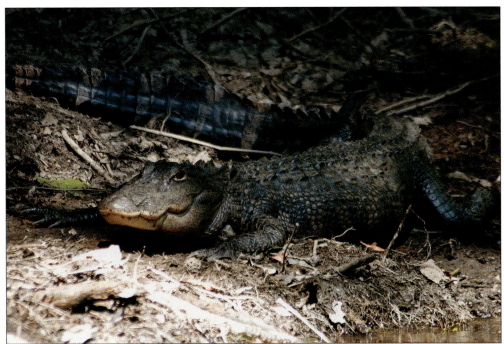

Alligators are not uncommon in the sloughs, ponds, lakes, and open waters found in the eastern end of the park. Some are 10 feet in length or greater. Gators are much less likely to be seen in the main part of the park due to there being few open-water habitats. (Photograph by Paul Angelo, courtesy of the NPS.)

The red-shouldered hawk is the park's primary daytime bird of prey. Noisy at times, it feeds on a variety of foods, including snakes, lizards, rodents, frogs, and invertebrates such as crayfish and grasshoppers. (Photograph by Ted Schantz, courtesy of the NPS.)

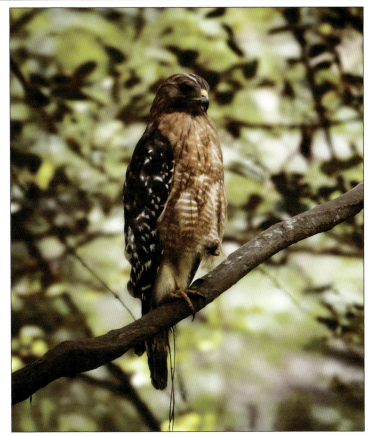

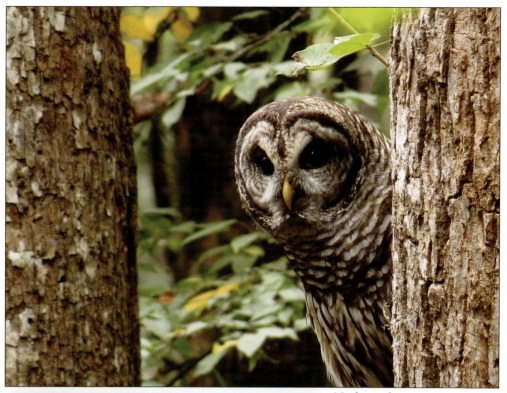

Nothing characterizes Congaree's swamp forest as much as the barred owl. They are very abundant and have an interesting repertoire of calls and hoots. It is not unusual to hear them during the day, especially early in the morning and late in the afternoon. Barred owls nest and roost in the many cavities and hollow trees found throughout the park. (Courtesy of Ron Ahle.)

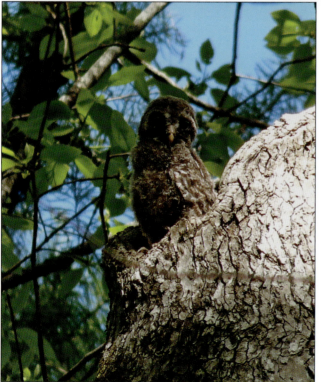

This young barred owl is old enough to begin investigating the outside world from the security of its nest cavity. (Courtesy of John Grego.)

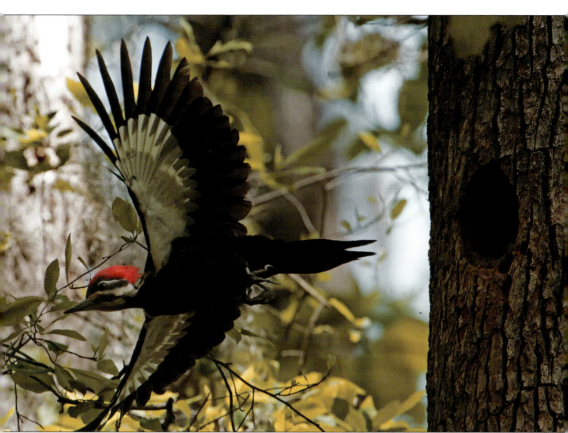

Congaree has one of the densest woodpecker populations of any forest in North America. One of the most abundant and striking species is the pileated woodpecker, shown here flying from its nest cavity. (Courtesy of Don Wuori.)

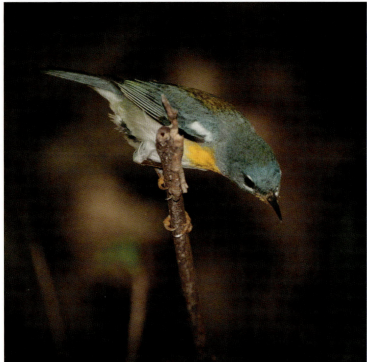

The diminutive northern parula warbler is the most abundant breeding bird in the park. It nests almost entirely within clumps of Spanish moss and has a territory of only an acre or so. It is one of the first spring arrivals after spending the winter in tropical America. (Photograph by Ted Schantz, courtesy of the NPS.)

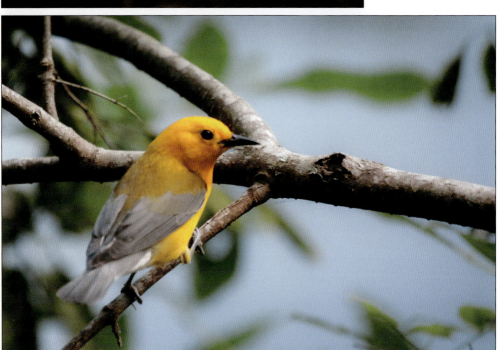

The golden prothonotary warbler is one of the park's most stunning birds. It prefers to nest near or over water in the cavities of cypress knees, trees, and low-hanging limbs. The "swamp canary," as some call it, spends the winter in tropical America and returns to the park in late March and early April. (Photograph by Ted Schantz, courtesy of the NPS.)

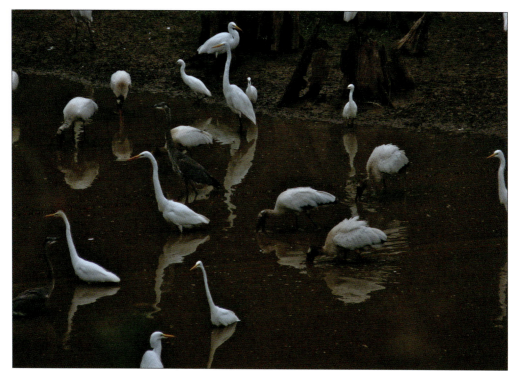

A medley of wading birds is attracted to a concentrated food supply found in receding waters at the east end of Congaree National Park. Shown here are four species: great blue heron, great egret, snowy egret, and the endangered wood stork. The storks have their beaks submerged in water, a characteristic feeding pose where the bird sweeps its bill back and forth and snaps up anything that comes into contact with it. (Courtesy of John Grego.)

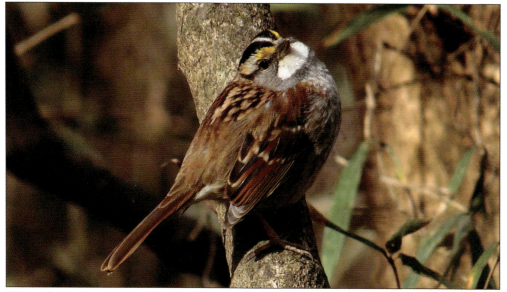

White-throated sparrows are common winter birds at Congaree. They prefer dense understory and ground cover such as thickets, vine tangles, and heavy patches of switch cane. (Courtesy of Ron Ahle.)

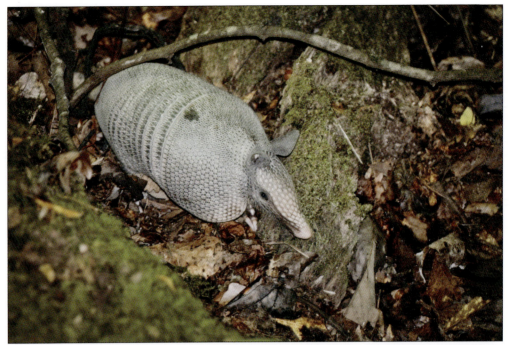

The nine-banded armadillo is a recent arrival to the park from parts farther south. It is chiefly nocturnal and feeds on a variety of plants and animals. During the day, it spends most of its time in burrows, often excavated in the soft earth of large root balls ("tip-up" mounds) from fallen trees. (Photograph by Ted Schantz, courtesy of the NPS.)

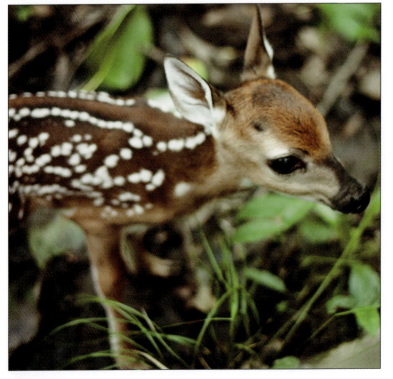

Deer fawns are occasionally seen from the park boardwalk in May and June. Seemingly abandoned, the fawn relies on its lack of scent and spotted camouflage to evade detection by predators such as coyotes and bobcats. The doe deer is always nearby and visits the fawn only enough to nurse. (Photograph by Ted Schantz, courtesy of the NPS.)

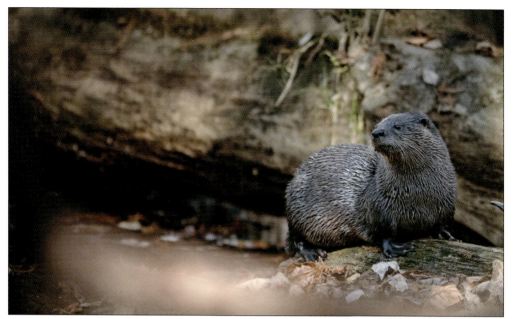

River otters are some of the most appealing and interesting mammals in the park. They are often found in small family groups in the park's deeper creeks, lakes, and back waters. A paddle on Cedar Creek affords the best opportunity to see them. (Courtesy of Joe Kegley.)

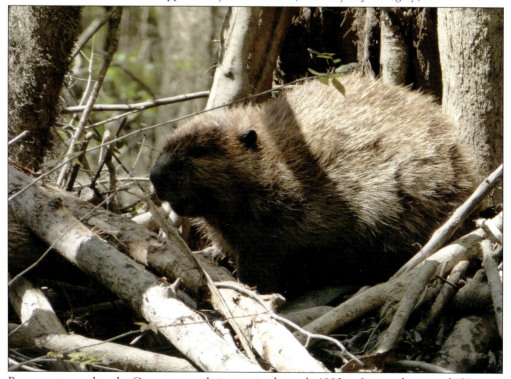

Beavers returned to the Congaree on their own in the early 1990s, after an absence of 150 years. They are native to the park, and their dam-building behavior has greatly influenced the park's environment, mostly for the better. (Photograph by John Cely.)

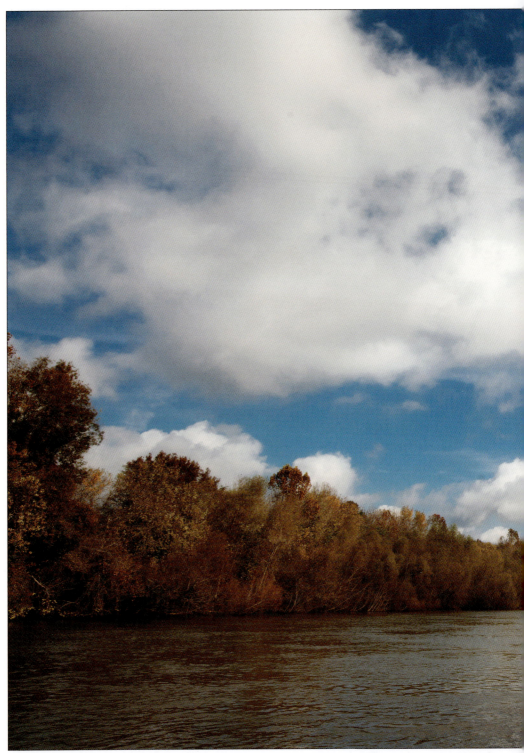
The Congaree River in early fall reflects solitude, serenity, and big sky. The park protects 28 miles of frontage along the north bank of the river, which was designated as an official Blue Trail by

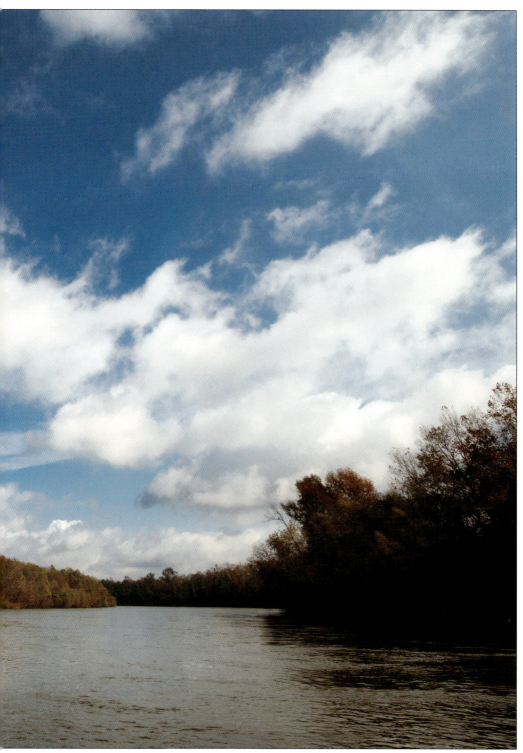

American Rivers in 2007. (Courtesy of jt-FINEart.com.)

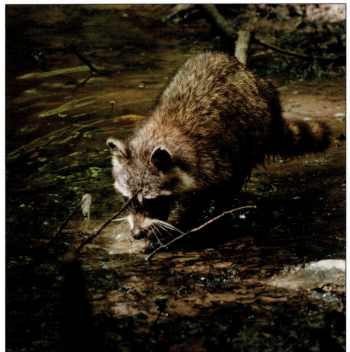

Raccoons are some of the most characteristic mammals of the park. They are especially common in the muck swamp, where ample food, notably crayfish, along with plentiful tree cavities for denning and raising offspring provide ideal habitat. Like many park mammals, they are mostly nocturnal but sometimes leave their presence behind in the form of muddy footprints on the low boardwalk. (Photograph by Ted Schantz, courtesy of the NPS.)

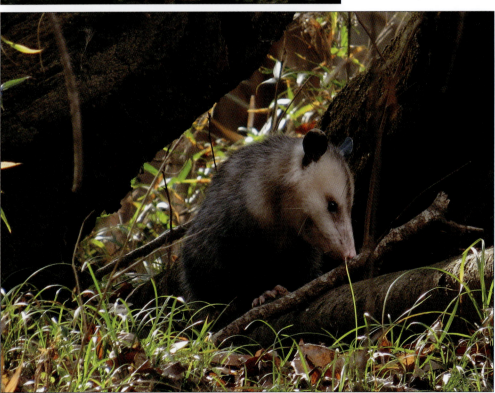

Opossums are common in Congaree. Like raccoons, they are chiefly nocturnal but are occasionally seen in daylight, like this one. (Courtesy of Ron Ahle.)

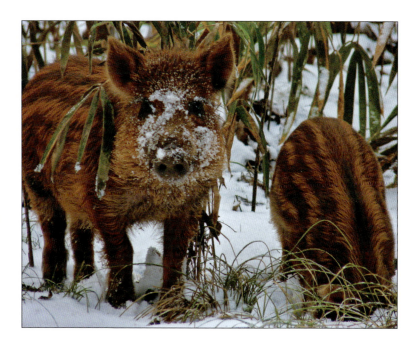

These piglets are learning how to forage in a rare Congaree snow. Feral pigs are common in the park and cause widespread ecological damage as well as posing a threat to livestock by spreading disease. (Courtesy of Rhonda Grego.)

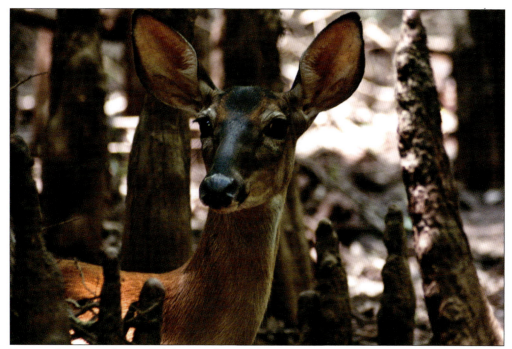

Despite their size, white-tailed deer can be stealthy and secretive when they need to be. Patience and some luck can sometimes yield a sighting from the boardwalk, like this doe hiding among cypress knees. (Photograph by Paul Angelo, courtesy of the NPS.)

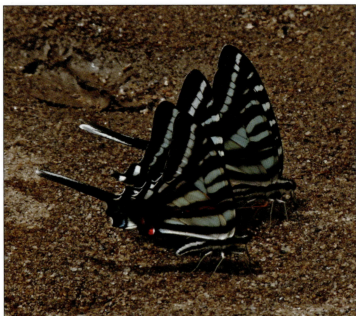

Zebra swallowtail butterflies are the park's signature butterfly species and certainly one of its most beautiful. The caterpillars feed only on the leaves of pawpaw trees. (Courtesy of John Grego.)

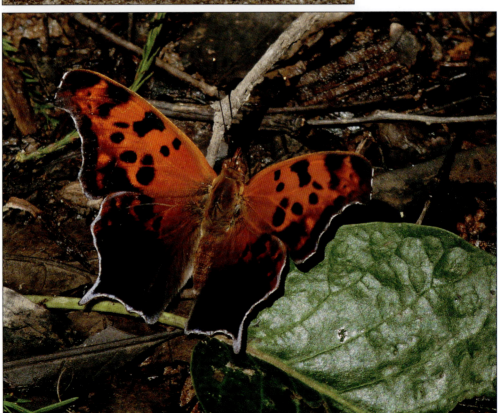

The question mark butterfly, so named due to a small silvery "question mark" spot on its underwing, is a fairly common Congaree butterfly. It hibernates as an adult and is one of the first to be seen flying on a warm day in late winter or early spring. (Courtesy of John Grego.)

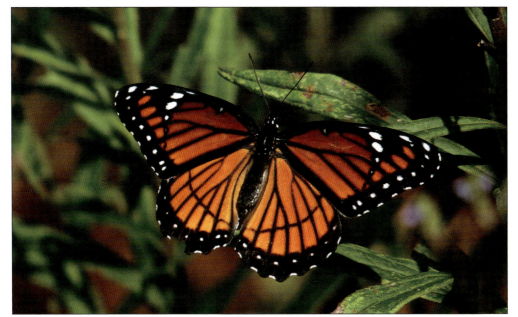

Sometimes confused with the more famous monarch, the beautiful viceroy butterfly mimics the monarch's coloration to avoid predation, since the monarch has a noxious taste. (Courtesy of John Grego.)

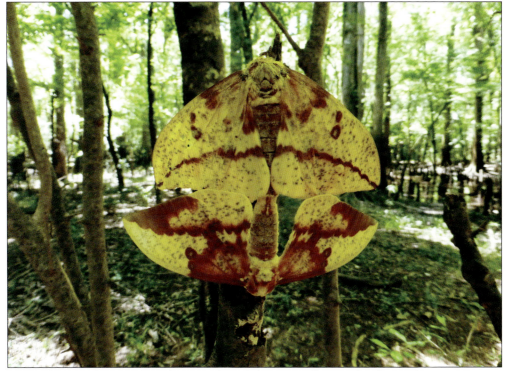

The aptly named imperial moth, a member of the giant silkworm family, can have a wingspan exceeding six inches. This photograph of a mating pair shows the female on top, while the more brightly colored male is on the bottom. (Photograph by John Cely.)

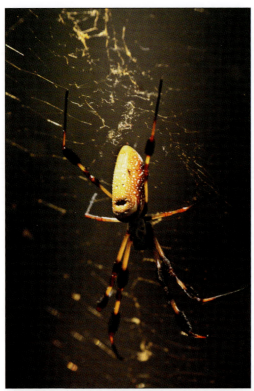

The golden silk orb weaver, sometimes called the banana spider, is one of Congaree's largest and most conspicuous spiders. Formerly found only in the Outer Coastal Plain, it has spread inland and was first found in the park in the early 1990s. (Photograph by Ted Schantz, courtesy of the NPS.)

The marbled orb weaver is an attractive spider that makes an appearance in late fall. Because of that and its yellow to orange coloration, it is sometimes called the Halloween spider. (Courtesy of John Grego.)

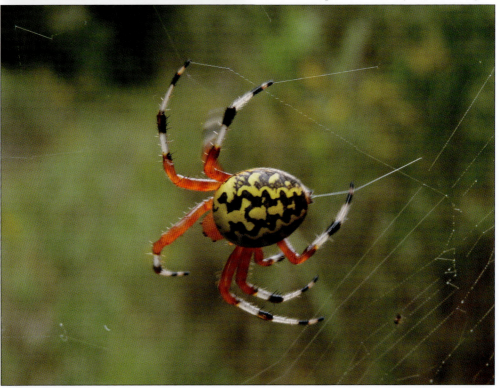

Indian pink blooms in May sparingly on the higher ridges and terraces within the Congaree floodplain. (Courtesy of John Grego.)

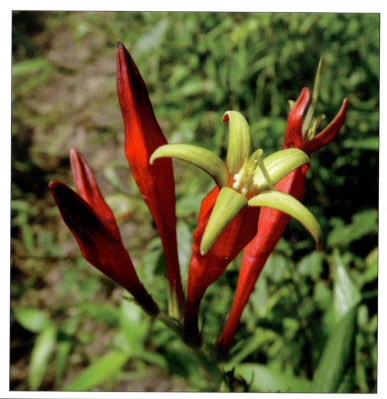

Carolina bog mint or Carolina birds-in-a-nest is an uncommon member of the mint family that prefers the moist conditions of Congaree's muck swamp. It is of state and federal concern. (Courtesy of John Grego.)

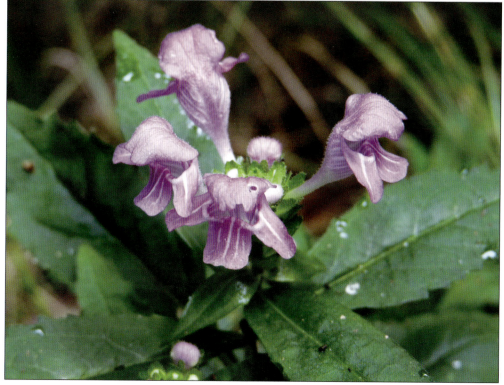

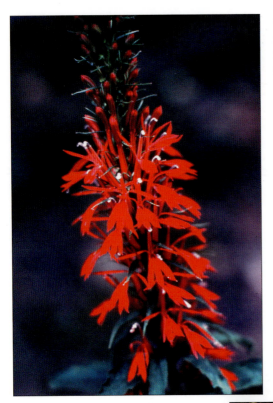

The cardinal flower almost glows when seen against a backdrop of green foliage in deep shade. It blooms in late summer in moist locations and varies in height from 12 to 40 inches or more. It is an excellent nectar source for hummingbirds. (Courtesy of the NPS.)

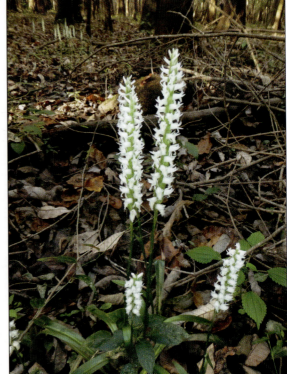

Ladies-tresses orchids brighten up the muck swamp in autumn. The low boardwalk is one of the best places to see them, growing on leafless stalks 6 to 12 inches high. They are more abundant some years than others. (Photograph by John Cely.)

Vines are some of the most characteristic features of the Congaree, and the park has more native species, 26, than any other national park. Cross vine is one of the most abundant species, and the flowers, blooming in early spring, are sought after by hummingbirds for their nectar. (Courtesy of Ron Ahle.)

Grape vines are another abundant species and give the park a tropical feel with their long, dangling aerial rootlets. They can get quite large, with some specimens being a foot in diameter at four feet off the ground. (Courtesy of John Grego.)

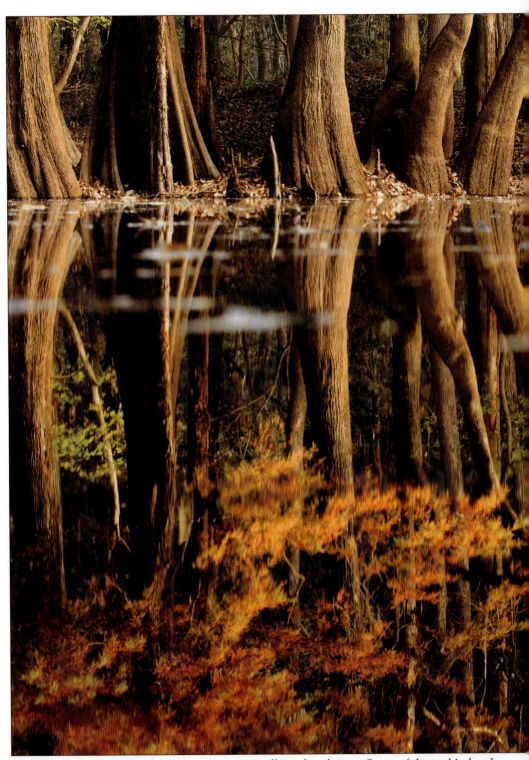

Autumn is when water levels at Congaree are usually at their lowest. Some of the park's sloughs, guts (basically shallow, winding, and twisting creeks), and ponds may even dry up. It is a photogenic

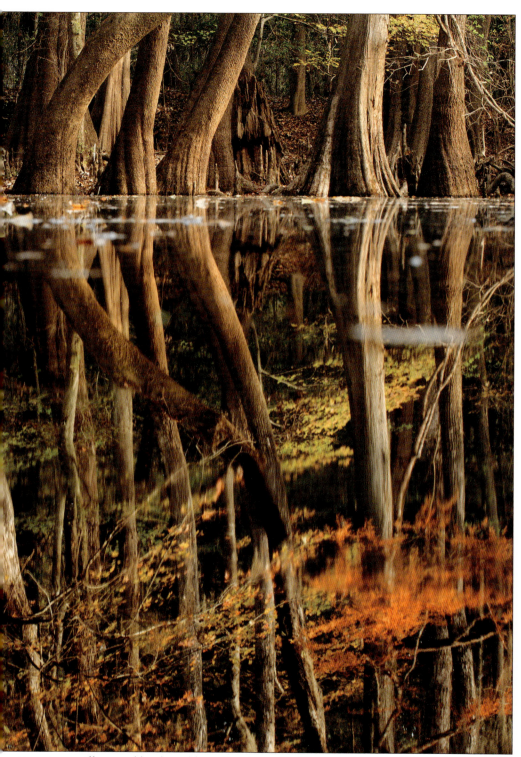
time, too, as illustrated by the golden reflections of bald cypress foliage at Wise Lake. (Courtesy of jt-FINEart.com.)

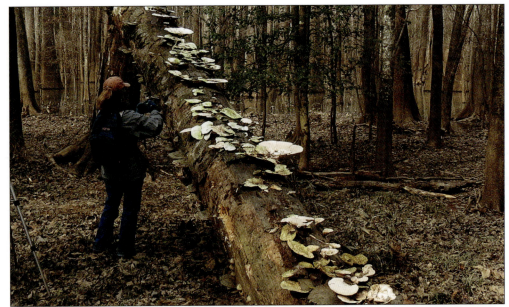

Congaree is packed with hundreds of species of fungi and mushrooms due to its dense shade, moist conditions, and abundant medium for growing fungi in the form of rotten and half-rotten logs and limbs. It is not uncommon to find large logs lined with dozens of fungi, such as the bone polypores found on this one. (Courtesy of Ron Ahle.)

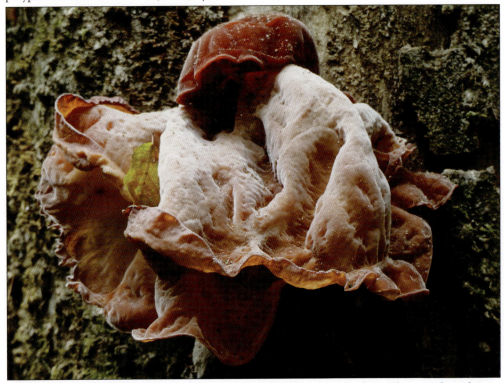

Mushrooms and fungi come in a variety of interesting shapes and colors. This wood ear fungus is a member of the jelly fungi family. (Courtesy of Caroline Grego.)

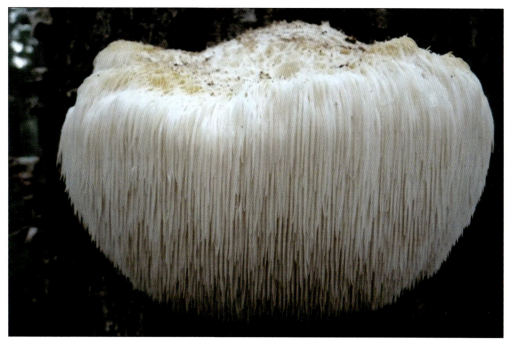
The bearded hedgehog, or lion's mane mushroom, is a striking fungus species usually found growing on the side of a tree trunk with decay. (Courtesy of John Grego.)

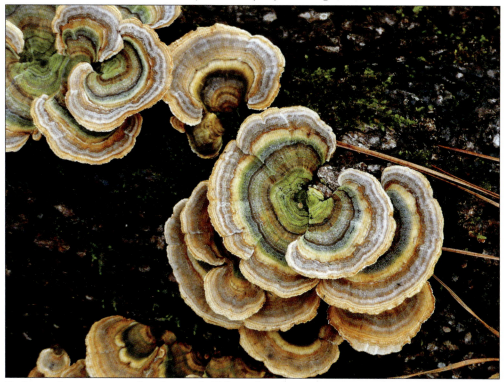
Turkey tails are common bracket or shelf fungi found on rotten logs and limbs throughout the park. (Courtesy of John Grego.)

Orange slime mold is highly visible when it first appears in the leafless Congaree forest of February. It is usually found growing on grape vines, often at the place where yellow-bellied sapsuckers have drilled holes in the vine's sapwood, which allows the sugary sap to feed the slime mold. It disappears as warm weather arrives in spring. (Photograph by John Cely.)

This is a slime mold with the telling name of dog-vomit slime mold (sometimes called scrambled-egg slime mold) growing from a rotten Congaree log. Biologists used to think slime molds were related to mushrooms and fungi but now put them in their own separate kingdom. Note the southern toad nestled in the log at the bottom of the photograph. (Courtesy of John Grego.)

The clear jelly, or snow fungus, is an eye-catching member of the jelly fungi family. It has another attractive relative often seen in Congaree, a bright yellow or orange jelly fungus called witches' butter. (Courtesy of Ron Ahle.)

Although most of the park consists of floodplain forest, about 1,500 acres of upland adjoin the floodplain. The ground cover of the upland pinewoods can be attractive in fall, when the sumac turns red and the bluestem grass is flourishing. The blackened charcoal on the trees is from a recent prescribed burn. Fire is an essential tool the park uses to restore the uplands to longleaf pine, one of the most threatened forest types in the country. (Courtesy of John Grego.)

A lush stand of cinnamon fern grows in a damp meadow on the edge of the Congaree floodplain. (Courtesy of John Grego.)

The cherrybark oak is the tallest hardwood species in the park. One tree, now dead, measured 160.2 feet high. The state champion cherrybark oak also has the largest circumference of any hardwood in the park at 24.8 feet. As shown in this picture, they have attractive fall foliage. (Courtesy of Ron Ahle.)

A setting sun highlights colorful fall foliage at Big Snake Slough. (Courtesy of Ron Ahle.)

The remains of a cut, 16-foot, century-old cypress log rest on top of a cypress stump, courtesy of heavy flooding. A good many of the cut cypress logs were too heavy to float by river to the sawmill and were called "sinkers." (Courtesy of Ron Ahle.)

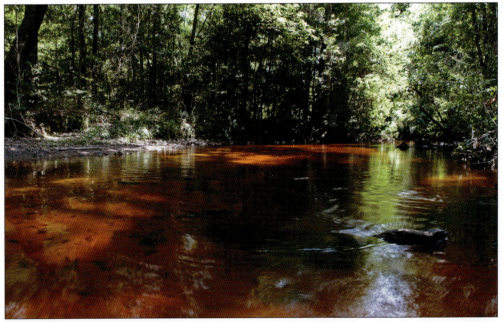

The shallow, tannin-stained waters of Cedar Creek invite a leisurely paddle by canoe or kayak on a summer's day. (Photograph by Paul Angelo, courtesy of the NPS.)

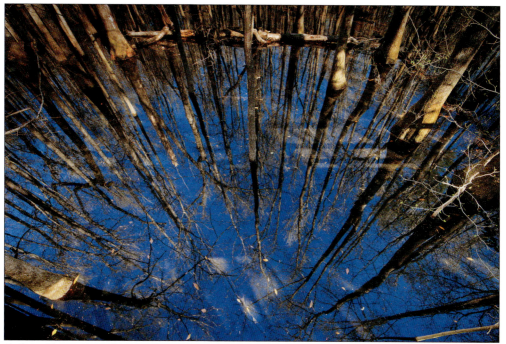

A deep-blue winter sky is reflected in the still, black waters near the low boardwalk. (Courtesy of jt-FINEart.com.)

Dwarf palmetto, a close relative of South Carolina's state tree, lends a tropical air to the Congaree forest. (Courtesy of jt-FINEart.com.)

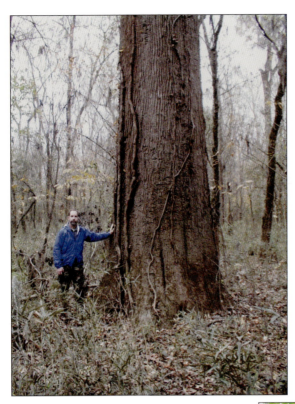

Congaree National Park supports the finest sweetgum forest in the world. This is the former national champion sweetgum, now dead, which was nearly 17 feet in circumference and more than 150 feet tall. About one in five trees in Congaree's bottomland forest is a sweetgum, and many are 12 feet in circumference or greater. (Photograph by John Cely.)

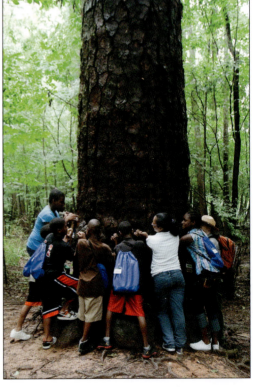

The well-known "Richland County Pine" growing next to the low boardwalk at Weston Lake is approaching three centuries of age. This one tree spans the entire official history of Richland County, established in 1785. It has survived countless wind storms, hurricanes, and insect damage and has been spared the one direct lightning strike that could kill it. (Photograph by Steven McNamara, courtesy of the NPS.)

Six

Park Activities

Hiking is easily the most popular activity at Congaree National Park. The park has more than 30 miles of hiking trails ranging from one to more than 10 miles. There is also a 2.4-mile boardwalk loop which is ADA-accessible with assistance. Ideal hiking periods, like for most park activities, are spring and fall. Winter hiking on crisp, cool days with blue skies can be pleasant and invigorating.

The park offers a variety of guided walks and ranger programs. One of the most popular is a short, guided canoe trip on Cedar Creek, the main waterway that winds for 15 miles through the heart of the park. Boats are provided and reservations required. For those more venturesome spirits with their own boat, the park has two canoe launches: one at Bannister's Bridge at the northwestern park boundary and one at South Cedar Creek Landing, seven miles downstream. Boaters should always inquire beforehand on water levels and potential obstructions, since portages can significantly increase travel time.

Congaree has two primitive campgrounds. Longleaf Campground is accessible by vehicle, while Bluff Campground requires a one-mile walk. Vault toilets are provided at Longleaf Campground and are planned for Bluff Campground. No running water is available at either site, and both require reservations. Backcountry camping (permit required) is an ideal way to enjoy the solitude and serenity of the park. Some restrictions apply, and no campfires are allowed.

Fishing is allowed (with a state fishing license) within the waters of the park except from bridges, boardwalks, and the Weston Lake overlook.

The park emphasizes youth outdoor education through the Junior Ranger Program as well as more structured programs conducted through the Old-Growth Bottomland Forest Research and Education Center. It also encourages volunteer participation in all aspects of its many activities, including maintenance and trail-clearing projects, greeting visitors and manning the front desk, conducting nature walks, and assisting with various research projects. Several "citizen-science" projects conducted at the park, including butterfly and bird counts, are done almost entirely by volunteers.

Visitors are encouraged to contact and stop by the front desk at the Harry Hampton Visitor Center to inquire about reservations, conditions, activities, and options before heading out.

There are more than 30 miles of hiking trails at Congaree that allow visitors an up-close-and-personal look at the beauty and mystery of Congaree's old-growth forest. The two-and-a-half-mile boardwalk loop is an excellent introduction to the park. (Courtesy of jt-FINEart.com.)

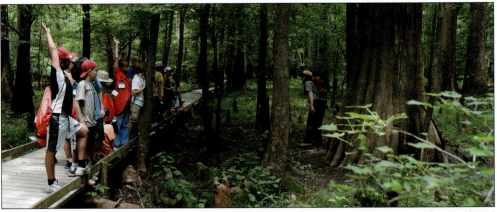

Ranger-led walks and other park programs are popular and informative ways to understand and appreciate Congaree National Park. (Courtesy of the NPS.)

Volunteers and interns play a big role in the park's mission. Volunteer John Galbary, shown here, conducts a nature walk. Known as "Mr. Congaree," Galbary is one of the park's longest-serving volunteers. He was awarded the President's Volunteer Service Award for an astounding 4,000 hours he has donated to the park. (Courtesy of the NPS.)

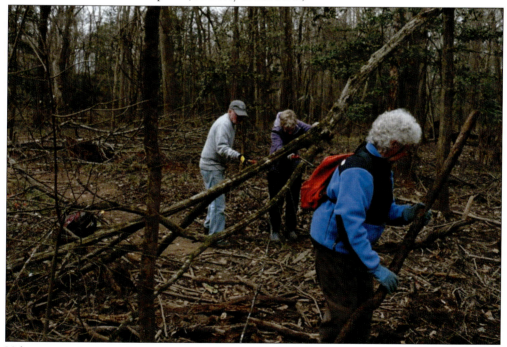

Volunteers assist in a wide variety of park activities, including maintenance, staffing the visitor center, conducting nature walks, and assisting with research projects. Here, volunteers help with trail maintenance and clearing. A recent tally showed that 530 volunteers and interns donated 18,500 hours of labor worth more than a quarter of a million dollars to the park in one year. (Courtesy of John Grego.)

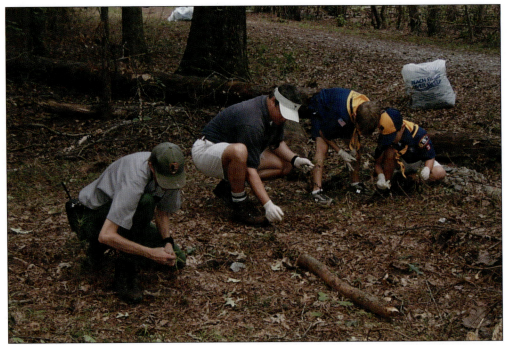

Scouts help out in the park too. These Cub Scouts are removing Japanese stilt grass, an exotic and aggressive grass that has gained a foothold in the park. Boy Scouts get involved with building footbridges and other construction projects. (Courtesy of the NPS.)

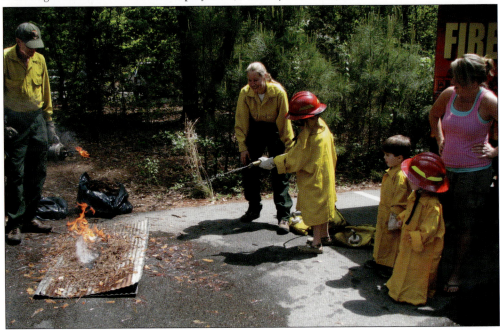

NatureFest was a popular park program conducted every April on Earth Day weekend. It featured a variety of exhibits and hands-on demonstrations related to the park's mission. Here, ranger Theresa Yednock helps a young firefighter put out a fire with a backpack water sprayer. (Courtesy of the NPS.)

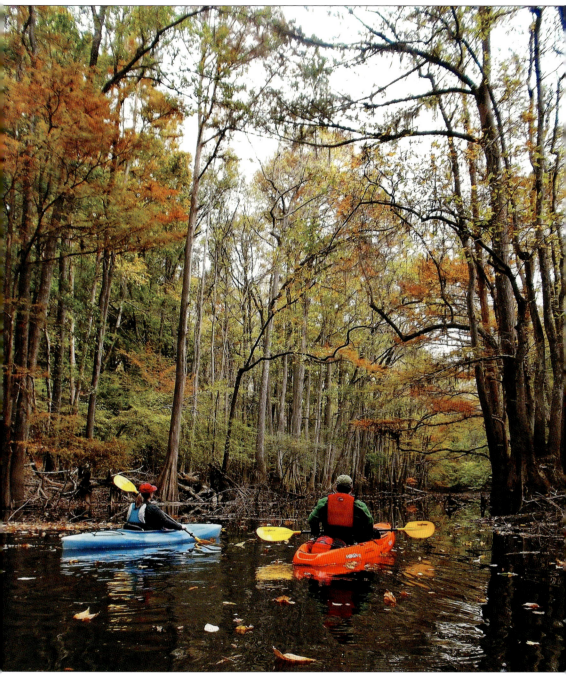

Canoeing and kayaking scenic Cedar Creek is very popular with park visitors and a great way to experience the magic of Congaree National Park. (Courtesy of J.T. Martin.)

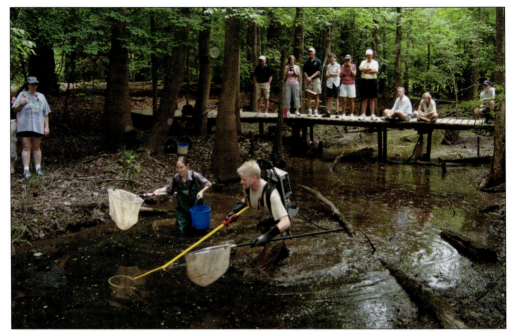

Fisheries biologist Leo Rose conducts a backpack electroshock demonstration for a NatureFest audience. The shock wand stuns fish and other aquatic life just enough to make them surface so they can be identified and counted for inventory purposes. (Courtesy of the NPS.)

These are not birders! Rather, they are participants in a Congaree butterfly count, sponsored by the Carolina Butterfly Society, the North American Butterfly Association, and Congaree's Old-Growth Bottomland Forest Research and Education Center. Close-focus binoculars have now replaced butterfly nets for identification purposes. From left to right are Carl Ganser, Brad Dalton, Marty Kastner, and Dave Kastner. (Courtesy of the NPS.)

Former park ranger Fran Rametta is called out of retirement to assist with the park's 2016 BioBlitz, a program that encourages youths and adults to get involved with natural history identification and data collection in their local parks. (Courtesy of the NPS.)

Congaree photography can be challenging but rewarding. These photographers are on an outing conducted by the Carolinas Nature Photographers Association. (Courtesy of Sparkle Clark.)

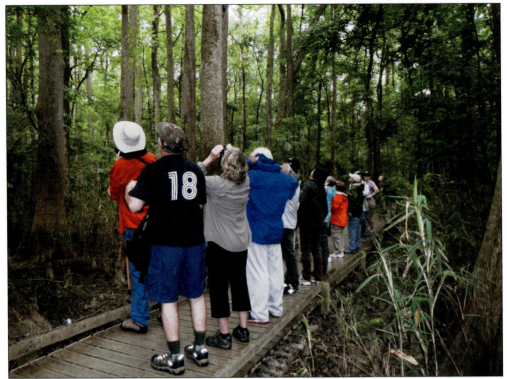

Birding is a popular activity at Congaree. Several birding events are conducted annually at the park, including this one for the Dawn Chorus Walk, held in early May. (Courtesy of David Schuetrum.)

Dr. John Nelson, curator of the A.C. Moore Herbarium at the University of South Carolina, periodically leads botany walks at the park. Nelson has a long association with the park that includes several botanical studies and surveys. (Courtesy of John Grego.)

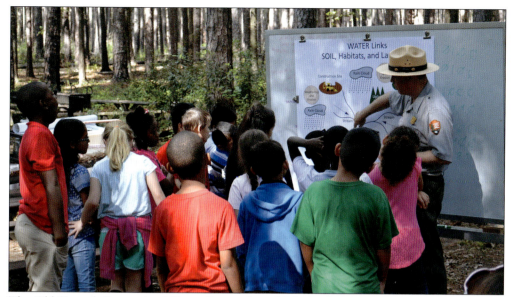

The Old-Growth Bottomland Forest Research and Education Center has partnered with the Columbia Museum of Art and many other organizations to provide a popular fall K-12 fieldtrip program called LEAF (Linking Ecology and Art of Floodplains). Local third-graders, who are studying soils in science class, explore the park's soils, do hands-on science experiments, and create landscape images. Between 2007 and 2016, the LEAF programs reached over 6,500 students. (Photograph by Zach White, courtesy of the NPS.)

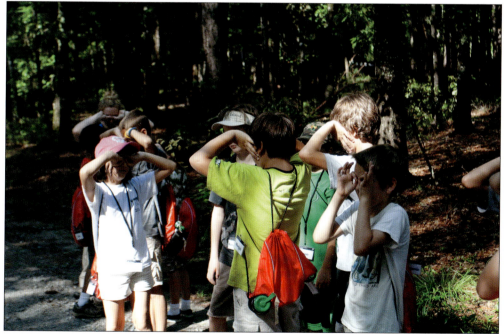

From 2008 to 2012, the Old-Growth Bottomland Forest Research and Education Center offered a Junior Ranger Ecology Camp. This free, one-week summer day camp program exposed youngsters to canoeing, hiking, tree identification, animal tracks, ranger careers, and, as seen here, observing nature using their own "owl eyes." (Photograph by Steven McNamara, courtesy of the NPS.)

Discover Thousands of Local History Books
Featuring Millions of Vintage Images

Arcadia Publishing, the leading local history publisher in the United States, is committed to making history accessible and meaningful through publishing books that celebrate and preserve the heritage of America's people and places.

Find more books like this at
www.arcadiapublishing.com

Search for your hometown history, your old stomping grounds, and even your favorite sports team.

Consistent with our mission to preserve history on a local level, this book was printed in South Carolina on American-made paper and manufactured entirely in the United States. Products carrying the accredited Forest Stewardship Council (FSC) label are printed on 100 percent FSC-certified paper.